Christopher J. Earnshaw

SHO

Japanese Calligraphy

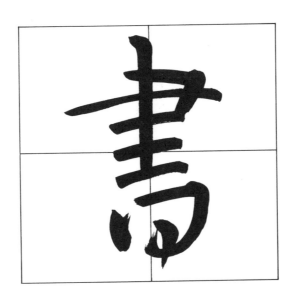

TUTTLE PUBLISHING
Boston, Rutland, Vermont, Tokyo

Published by Tuttle Publishing

Copyright © 1988 by Charles E. Tuttle Publishing Co., Inc.

Library of Congress Catalog Card. No. 88-51194
International Standard Book No. 0-8048-1568-2

First printing, 1989
Fifth printing, 2000

PRINTED IN SINGAPORE

PREFACE

Calligraphy is an art form that has been studied for over three thousand years. The line, being the basis of all Oriental art, has, of course, a deep relationship with the art forms of countries around the world. I believe a knowledge of calligraphy will be an important string to one's bow in the understanding of Japanese culture and in making friends with Japanese people.

For over thirty years I have endeavoured to make Japanese calligraphy easier to understand and appreciate, so that it will appeal to not just experts, but people of any country. As an explanation of calligraphy this book will probably be the first introduction for people other than Japanese and Chinese, and through this book the people of countries all around the world will have a chance to experience a little of the world of calligraphy, that seems so simple, but that is in reality a rich and rewarding study. It is the author's desire that this book will help in the understanding of the origins of Japanese culture.

序

書は、三千年にわたって研究された線の美術である。　線は東洋のすべての美術の基本となっているが、もちろん世界のあらゆる国の美術と深いかかわりあいを持っている。日本人と一歩でも親しさを増し、日本の文化の理解を一段と深めるためには、書を知ることが大きな力となるものと私は信じている。

私はこれまで三十年間にわたって、日本の書をより分りやすく、また親しみやすくし、専門家だけにとどまらず、世界のあらゆる国の人々にアピイル出来るものにしたいと心から願って来た。　書の解説書としては、日本と中国以外の人としては初めてのものである。　この本によって世界のさまざまな国の人たちが、単純でありながら奥深い書の世界に少しでも踏み込むチャンスをつかみ、日本の文化のルーツの理解に役立てば著者として本懐である。

Ohtei Kaneko

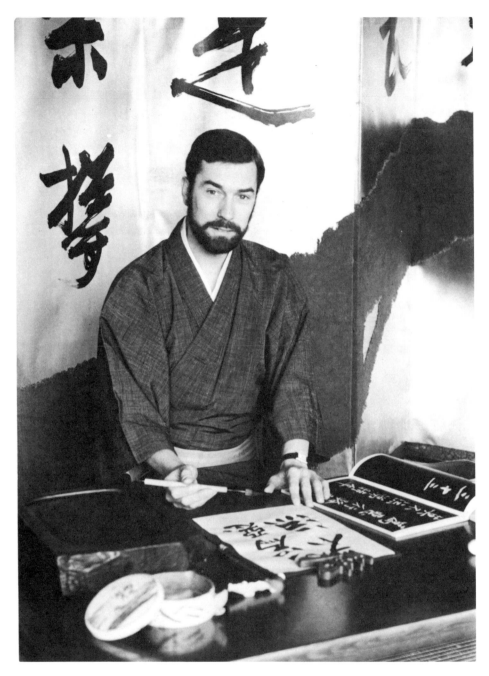

Born in Oxford, England in 1953, Christopher Earnshaw studied calligraphy and Japanese studies at Daito Bunka University in Tokyo and classical Japanese and Chinese through London University. He has held several exhibitions both privately and as the group **Terakoya**, in Japan and abroad. Receiving his Master's licence **Shodō Kyōjusha Shikaku Ninteisho** in calligraphy in 1978, he exhibited several times in the Mainichi exhibition, the first time being in 1979 and received a gold prize in the twentieth All Japan Calligraphy Exhibition. Presently he lives with his family near Kobe, Japan and works for a British pharmaceutical company.

TERAKOYA

This is a name given to a type of school run during the Tokugawa Period (1603 - 1868) by samurai to teach the local children the three R's. In this case that meant reading **yomi,** writing **kaki** and arithmetic **soroban.** The school was usually a designated place, and likely as not a temple would lend rooms, hence the name "children of the temple room" **terakoya.** A famous mathematics textbook was written for the Terakoya by Yoshida Mitsuyoshi called **Jingōki.** In it he introduces the concept of compounded multiplication, **nezumizan.** Can you answer one of the problems he poses? If a pair of mice had twelve offspring every month, half of which were female, and every month those offspring also bore young, after twelve months how many mice would there be?

The Terakoya this author runs is a group of non-Oriental calligraphers who attempt to further the art through group study and exhibitions and thereby promote in themselves and others a cultural awareness and deeper understanding of Japan.

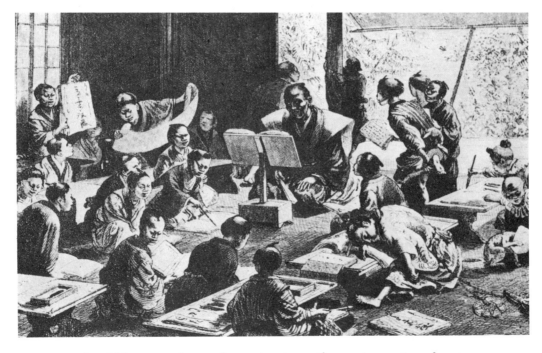

An illustration of a nineteenth century **terakoya**

Answer: 27,682,574,402 Mice

CONTENTS

A Foreword

Working the inkstick slowly backwards and forwards on the inkstone, I study what I am going to write. My eyes drink in the slender lines, the power, the rhythm, and the vitality there. Already in my mind's eye an invisible brush is forming the characters on the untouched paper.

Facing the paper and reaching for the brush I experience a calm, relaxed feeling. My whole being is concentrated on the small square of paper and as I contemplate the possibilities of form, balance and rhythm open to me, the paper seems to grow in size. I write one copy and then another and soon the brush has become an extension of my inner self. The brush translates into black and white through the simple medium of a line, a form many artists cannot express even with a rainbow of colours on their palette. Being totally engrossed in the potential and the problems of constructing the character, the sensation of time just slips away. I write thirty or forty copies and my subconscious quietly ascends a crescendo of excitement as I near the goal. Finally I have it. A copy that is perfect in form and bursting with energy. Each time I look at it I see that my feelings of the moment have been put down on paper for eternity. This feeling communicates itself not only to me but to others as well. The better the writing, the more understandable my expression.

This passage may seem very difficult to comprehend now, but the more you practice the more vivid its meaning will become. In this book I intend to introduce the reader to the method and show the way to a full appreciation of calligraphy in its many forms, both Japanese and Chinese. I expect that he will in the end be able to create meaningful works of art himself. Calligraphy is very rewarding not just on an artistic level, but also in a spiritual sense. Many of those who have had experience in Zen meditation, myself included, confirm the analogy. Indeed many of the most famous practitioners during calligraphy's 3,500 year history, have been priests.

Calligraphy, a major art encountered every day in the Far East, has been largely overlooked by western visitors in search of Asian culture. Calligraphy is not merely the exercise in good handwriting that many people believe it to be, but rather the foremost art form of the Orient. The Tea Ceremony **Sadō** and Flower Arranging **Kadō** are, being quite accessible to outsiders, the best known. The object of the Tea Ceremony is in the experience of a moment and that of Flower Arranging in creating a work that lasts a few days, but in calligraphy **shodō**, the peak of the moment and the enduring pleasure of days are combined.

Let me now guide your brush from the simplest examples to a place where you can write with fluency and confidence. First though you must learn the fundamentals and then you can venture on with your own creations.

1

The Beauty of Japanese Calligraphy

There is no riddle to calligraphy; it is simply a formula which combines the skill and imagination of a person who has studied intensely the combinations available to him with only lines. His is but to build wonderful structures without hesitation, mistake or variation with those simple lines. The pure power and rhythms of nature influence the artist and he interprets this to infuse his characters with "life".

Good calligraphy is instantly discernable from bad to the trained eye, but as beauty is not an absolute quality, it is very difficult to demonstrate why this is so. Nevertheless here are a few guidelines to help explain:

a) There is a natural balance in both the characters and the composition as a whole.

b) There is an abstract beauty in the line which may be subdivided and evaluated thus:

1) Straight lines are strong, solid and clear.

2) Curved lines are delicate, feminine and mobile.

3) There is a variance in the thickness and thinness of the lines.

4) The amount of ink on the brush or the lack of it (cf. **kasure**) is consistent throughout the work.

5) The size of the characters are of a scale which give a pulse to the work.

6) The colour of the ink, **kasure**, the pulse and the quality of the lines combine to form **rhythm**!

Calligraphy provides a two-fold pleasure to the beholder; an aesthetic visual stimulus as well as an aural excitement. Here, however, we will concern ourselves with only the visual aspect. As a single stroke may not be touched up or rewritten, any lack of talent is immediately apparent. If any one of the above points is missing, it is as glaring as discord in a Bach concerto. This perfect coordination between hand and mind takes years of practice. For all that however, legibility, or as we think of it neatness, is not a controlling factor.

Many people think of calligraphy in terms of dancing, but I prefer to think that classical music, being stricter, is a more apt comparison. A pianist achieves success or not as the case may be, through his interpretation of the myriad notes of a piece of music. A poem lies beside the calligrapher like a piece of music. Likewise his success depends upon the appeal in its presentation.

The pianist peers at signs beneath the notes telling him to crash loudly, tinkle softly or race ahead. In the same way the calligrapher receives clues in the meaning of the words. Both the musical piece and the work of calligraphy may be "recorded" for posterity, one on acetate and the other on paper. It is the person who owns these articles who has the privilege of a private experience when he listens to the music or gazes at the calligraphy.

As any pianist will tell you, compositions must adhere to general rules or the result becomes nonsensical. Introducing rules for a keener appreciation of calligraphy and the means, if possible, to act as a springboard for one's self expression through the medium of the craft, are the aims of this book. One cannot forever be playing Chopsticks on the piano while all those sonatas are waiting to be played.

The Chinese attach great importance to their handwriting, not only because it once opened doors to higher positions in government by way of the Civil Service examinations, but also because it is believed that one's hand reveals a great deal about one's character. Graphology, the art of inferring character through handwriting, is an established practice in China.

In the West calligraphy, "a beautiful hand" (copperplate, like engravers use) was supposed to suppress eccentricities in style. The Chinese, on the other hand, attempt to bring words to life, to actually endow them with "character." Styles of handwriting are highly individualistic and differ from person to person, rather like the present state of handwriting in the West.

Calligraphy is highly involved yet simple in its own way. It is this paradox that offers the challenge. The finished product is simple, but the elements that go to make it up are not. Careful choice of the medium and subject, years of study and research, composition and lesser details including choice of a seal **inkan**, backing **hyōgu**, and framing all play a role. To the unitiated person it appears the simplest product, but to those with an understanding of calligraphy it signals its pedigree. That it has a definite attraction is unmistakeable for often on visiting galleries one sees people gazing up at calligraphy, totally absorbed by lines and dots that bring to the mind of a Westerner such names of masters of the abstract as Jean Miro or Paul Klee.

Kōkotsumoji

4

What you will need

Ideally you will be able to obtain the "Four Treasures of Calligraphy" **bunpō shihō**, namely a brush, some paper, an ink stick and an ink stone. In the Orient these are readily available, but as they are virtually unknown commodities in many places of the west, a brief explanation is required, (see appendix).

The Brush **Fude**

Brushes come in various sizes and qualities, but for the beginner the best quality is unnecessary.

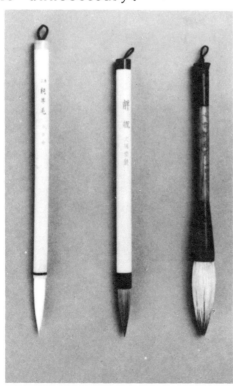

Nevertheless there are some things to keep in mind when buying a brush. The shaft of a brush is normally made of bamboo into which bound hairs are inserted and glued. This shaft ought to be 18 to 20 cm long and the bristles 5 to 6 cm, an overall length of about 24cm. Also examine the width of the bristles where they join the handle-about 12mm is ideal. If you happen to be in a Japanese shop ask for a **chū-bude** (middlesized brush). The hairs of brushes are starched so that they form a point. Do not buy one that has had the starch worked out as they are very difficult to control while you are writing. Still you will notice the shop probably has both starched and loose haired versions of the same brush. Pick up the "opened" brush and look at it carefully. Pull it gently through your fingers to see if the hairs come loose, or when inverted the hairs do not either collapse to one side (too soft) or seem to be hard and springy like the bristles of a hair brush. Ask the shopkeeper for a brush made of sheep's hair **yōmō**. These are the best and will tend to have white hair instead of brown or black. An expensive one is unnecessary, but one that is too cheap is really more expensive in the long run because the hairs moult, the glue may rot and from time to time the bamboo may split. An inexpensive one is quite adequate. There's a saying that goes, "Kobo fude o erabazu", meaning the famous calligrapher, Kobo Daishi never chose his brush, but wrote with whatever was at hand. Once a professor at the university where I was studying calligraphy, wanting

to illustrate a point, had no brush within reach, so he rolled up a piece of paper and used that instead. For the beginner though I recommend using a brush.

The Paper **Kami**

The paper used in calligraphy is different from that generally available in the West. It is much thinner and more textured than ours, has little sheen, a markedly rough reverse side and is also absorbent. The size to use for **shosha** or **shūji**, copying works for practice, is 24cm by 34cm, but if nothing that size is available, at a push newspaper can be used. Try to get some without distracting articles all over it. Japanese paper comes in set sizes and the size you will use is called **hanshi**. In ancient days paper was a luxury and many people could not afford it. The Chinese Han Dynasty calligrapher, Cho Shi, always practised on fabric so he could wash it out and start again. The result was he turned the pond, in his garden where he washed his cloth, permanently black.

The Inkstick **Sumi**

Inksticks look like bars of black chocolate, and are sometimes decorated with motifs and gold writing. The average size is about 12cm long, 4cm wide and 2cm thick. In poorly lit surroundings they are easily distinguishable from chocolate by their musty smell and the very Chinesey boxes they come in. Much of the best ink comes from China and has rings on the top showing the degree of blackness, five being the blackest.

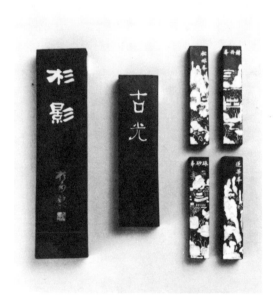

Making the ink is a laborious task, but the effort is worthwhile as the end product is a good quality ink. Recently great advances have been made in the manufacture of ready made liquid ink called **bokujū**. Though it makes

6

work easier, its colour and quality are inferior by far, as you will come to realise during your studies. Most calligraphy teachers will not permit the use of **bokujū**, for the above reasons and also for a spiritual reason. They maintain this world runs at too fast a pace and the simple act of making ink will clear the mind of extraneous worry and help calm the spirit. The feelings of a nervous, anguished or hurried person is reflected in his calligraphy.

Indian ink, poster colours, or the like cannot be used as they do not dry well enough or congeal too quickly.

The Inkstone **Suzuri**

The inkstick is rubbed over a shallow slate dish with a reservoir at one end. This receptacle ought to be large enough to hold sufficient ink for your work.

Amounts of ink should neither be so small that all the ink will disappear as soon as you put the brush in it nor so large that it takes all day to make sufficient amounts. An interior dimension of an actual grinding stone of about 8cm x 14cm is just right. Stones that have been machine cut to a rectangular shape are far cheaper than those that have been carved by hand from natural stone.

Other Things

Most of the above tools are available in supermarkets and folk craft shops in the Chinatowns of large Western cities. They often come in ready made sets, but have a look inside to see what you are getting before you buy.

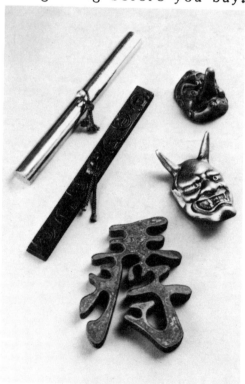

You will need three other small things that can be prepared at home-a paperweight, a container of water for adding to the ink, and a piece of

7

good quality felt for an **shitajiki** undercloth. Normally this cloth is in a restful colour such as green, dark blue or black and it is to be laid under the paper. The ink will often seep through the paper and as felt repels water, the ink has no chance of getting through to the table. Anything 28cm x 36cm or larger is fine.

All should be laid out in front of you (as in the example) with the work you will be copying, the **tehon**, (e.g. the examples given later in the book) at your left. The ink and brush should be placed on your right. This will facilitate writing and save knocking over the indelible ink. It was easy to recognize the house of Chinese calligrapher, Chung Yu as everything from the rocks and trees in the garden to the floors and doors of his home was spattered with ink. Beware!

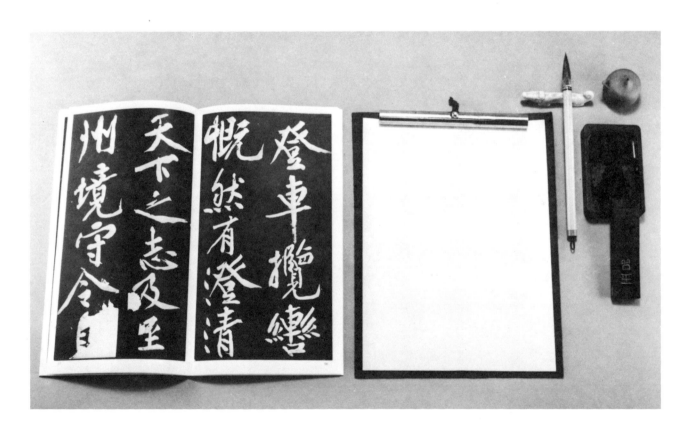

Things to know
before getting started

There are only two rules in calligraphy, easy to remember, but hard to carry out sometimes. Firstly the characters must be written in a certain stroke order. There are general rules on this, but like the best kept rules exceptions do exist. The stroke order has been given for the examples in the text. Secondly the characters must be written only once. That means no altering, touching up or adding to them afterwards. Unlike oil painting where mistakes may be scraped off or painted over, in calligraphy mistakes must stand as they are. This is what gives the characters "life" and movement; writing a stroke twice **nijūkaki** kills the feeling and burdens the character down. Occasionally the ink runs out in the middle of a character **kasure**. This is permissible so long as the form of the character remains discernible.

It is advisable to make lots of ink and any left over may be put in a jam jar with the top screwed on tightly to slow evaporation. Another idea is to slip a couple of copper coins in with the mix as this will help stop the ink going off.

While making the ink study the example carefully so that you may fully understand the stroke order and what has to be done. This enables you to begin as soon as the ink is ready without interrupting the state of concentration you have built up while making your ink.

The average number of characters written on a sheet of **hanshi** with a middle size brush is either five or six. When writing five, space them as you would for six, but leave the last square blank as this is where one normally puts one's name. More on this is explained in the section on **katakana**. An aid to laying the characters out is to fold the sheet vertically in half giving a right and left sector. If this is not helpful enough, the paper may be folded into six sections so that each character will have its own area. The only other possible method one can use is to place a grid on the **shitajiki** visible through the paper. This provides the best guide, but developing too much dependence on it will make for bad habits. Anyway, when you practice the examples in this text make it a custom to write six characters to a page.

Paper is, it must be remembered, expensive so even if you have made a mistake do not throw the paper away too hastily. You can still write over the same letters many times until you have them down pat. This is beneficial also because you can then concentrate on a single character or even a single stroke of a character in these moments without having to think of the entire composition. Do not expect to be able to write a good copy the first time. Only a master calligrapher can do that. Write the same example fifty or more times. Then you will understand its every twist and turn by heart and will be able to write it without even referring to the model **tehon**. The calligrapher Chao Meng Fu of the Yuan

Dynasty was said to have worn out the sleeves of all his garments because he was so diligent in his practice of the fundamentals.

The Chinese copy their teacher's example by several different methods. Most popular among these is to place their paper atop their teacher's example. This is not a good idea because in time the model will become illegible and one will then end up practising one's own mistakes. The aspiring student too, may be likened to a little fledgling learning to fly; he gains no confidence by copying directly. It is almost as if he does not jump sooner or later, he will never learn to fly. If it puts off leaving the nest forever, the initial jump only becomes all the more difficult. A youngster may distract his watchers with a lot of fluttering and unintentional aerobatics, but that is the fastest route to learning. In Japan copying the model directly is regarded as cheating and most teachers will be able to tell the difference.

In the **gyōsho** the characters seem to have been dashed off quickly, but that is not the case. What gives this impression is the undulation of the stroke. It is thick and thin and in places the amount of ink on the brush the ink seems to have run out **kasure**. The fact is, it was written that way intentionally. Writing in this style is rather like driving, go fast on the straights, but slow down on the corners! Even in the other styles of writing the speed is not the important

thing; keep a constant speed, not too fast else one has no control and not too slow as either the ink floods out and drenches the paper **nijimi** or the shaking of your hand will be evident to the viewer.

Teachers use an orange-red ink **shuboku** to correct copies of their students' work. Corrections lead the student to realize that a copy need not be exactly the same as the model so long as the rules of writing have been respected. Here is where personal interpretation comes into play. Sometimes a character written exactly the same as the model will be corrected where it appears to conform to the model and reasons for this correction are various and intuitive. They are learned only after long experience. The most common fault is in characters that may be viewed as a pair. Individually they are good, but as a pair they are lacking in some way. When studying by oneself there is of course no teacher close at hand so it is only by writing copies many, many times and comparing them to good models that one can begin to perceive one's weaknesses. Another good method is to turn the paper around and look at it from the back. The bad areas seem to stand out then. When you have managed to write a good copy, place it aside for a couple of days and then come back to it once more. It is certain that by looking at it afresh your sense of appreciation will have changed.

A brush usually has a life of about three years if well treated. This means washing it thoroughly after

writing and taking care not to wash out all the starch. After wiping, the brush should be hung up to dry. Wash your **suzuri** ink slab too as the ink will dry into a solid cake if you do not.

Left handed people have to learn to write with their right hands because holding the brush in the left hand leaves the hairs pointed the wrong way and the correct pressure cannot be applied to the strokes. The same skill may be achieved, simply spend more time on the elementary steps.

Actually starting

Place your paperweight at the top of a sheet of paper and lightly place the fingers of your left hand near the bottom left of the sheet to hold the paper taut. Grasp the brush as shown.

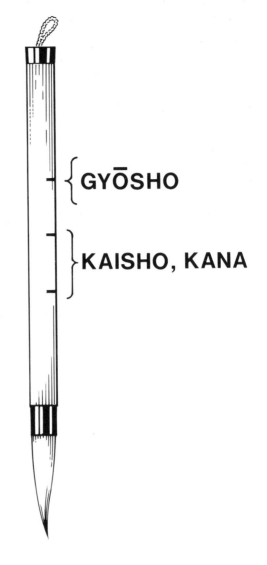

GYŌSHO

KAISHO, KANA

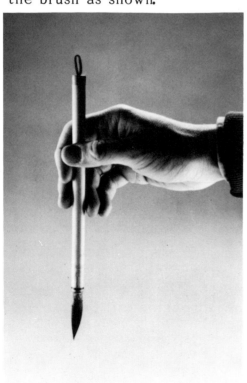

It should not feel awkward, but in time become a living extension of your arm. Allow the power to flow down your arm on to the paper by using the brush as your conductor. The thumb locks the brush by pressure against the upper joint of the forefinger. Forefinger and middle finger exert pressure inwards and the slightly crooked ring and little fingers exert pressure to the outside. The brush should be held between a third and halfway up for most styles of calligraphy and as much as two thirds of the way up the shaft for writing semi-cursive **gyōsho** because the brush will require more latitude of movement.

11

Observe the following points and you should find the brush doing just as you want.

1) Keep the palm open

2) Always keep the shaft of the brush upright

3) Keep the wrist and elbow off the surface of the table

4) Hold the brush firmly without being tense

The well known calligrapher Ogishi once crept up behind his son Okenshi to try to snatch the brush from his hand, but without success. This prompted him to remark that his son had the makings of a great calligrapher, which indeed the son did become.

Use only a third of the length of the hairs for writing. That way ink is absorbed and the springiness of the tip retained. Imagine it like a three part spring, soft at the tip, mildly stiff for the remaining length of the hairs and hard at the shaft. This is the ideal combination. If only two degrees of torque exist, the spring is lost. This "backbone" is useful at first in•writing. Only at a more advanced level does the need for an "unstarched" brush arise.

When practising, place your wet copies between the pages of an old newspaper to dry or soon all your floorspace will have been used up. Reorder the point of your brush now and then on the flat of your inkstone so all the hairs of the brush come to a sharp point even when you are

in the middle of writing a character. If wet circles appear around the boundaries of the characters then there is too much water for the amount of ink in the mixture. This may be true even if your ink is pitch black. Keep in mind that calligraphy is composed of two components:

Discipline- evidencing good construction in the writing of your characters, giving the lines a definite quality, training one's eye to be able to look deeply into the models to evaluate them and developing the will to persevere in your work.

Cultivation of the art- choosing suitable styles forms, themes and medium, being aware of historical precedents and finding the necessary inspiration.

What goes into a completed work **Sakuhin**

The elements of a work include:

Theme **shudai.** The copying of a famous work **rinsho** of another painter will very rarely be the theme of one's work.

Inspiration **reikan** is the most important thing in a piece. If inspiration is lacking even something so obvious as the character for "hot" can appear quite cold.

The structure of the character **kekkōhō** refers to the direction of the stroke, the lengths or lines and dots and how corners are negotiated,(see appendix).

Kūkan refers to the white

space between characters and the characters in relation to the paper, and **kanga** the integral spacing of the lines and dots in the character.

The quality of the line **sen.**

The colour of the ink **bokushoku.**

The title **dai** though this may often be pre-determined since if one writes a poem it will already have a title. Nothing more can be said except for the interpretation of the brush.

These six elements are governed overall by two vital factors, harmony **chōwa**, a term encompassing a large area, but including control of ink and its colour, rhythmic qualities produced by the fluctuation in size and weight of characters and a balancing of all the factors above plus emotion **jō**, an abstract quality difficult to explain in words, but one I have tried to demonstrate with a few lines below.

A work should never be dull. Rather it should be refreshing, invigorating, exciting, stirring, proud or strong and, however you may express your feelings, always meaningful.

Presently three types of work are generally acceptable at exhibitions in Japan: calligraphy **sho**, carved seals **tenkoku** and carved calligraphy **kokuji.**

Further Elements

Above I spoke of calligraphy **sho** and it must be realized that by this the Japanese mean anything that is written with a brush based on characters, but not necessarily just characters. The work may be in any style, but should not be a mixture of styles unless the characters are to be written separately to stand side by side as contrasting forms. The text **goku** of the piece of prose or poetry must be written from right to left. Calligraphy may be divided into two main categories, not to be confused with styles: **kanji**, Chinese characters, and **kana**, the Japanese syllabary. In **kanji** the theme is generally a Chinese poem or prose, whereas **kana** will concentrate on poems of exclusively Japanese origins like the **Manyōshū**, (see appendix).

Placing the Seal **Inkan**

Seals are carved with one's name or appropriate characters and used as a signature. That dot of red is the touch that finishes off the work and gives it a feeling of artistic completion. How many different seals to use and where to place them on the work are personal decisions. The latter of these two choices is the more difficult of the

problems. The trick is to look at other works and compare your own solutions. There are no hard and fast rules, but a badly placed seal can make a work seem heavy or appear unbalanced. Works will always have a seal even if the formal signature is absent. In the case of long written works **jōfuku** however, the majority will have both. Furthermore they will often have a few lines at the end **rakkan** commemorating when and where the work was written. (see appendix)

Once finished, a work should be equipped with a backing **hyōgu** to give it support and remove wrinkles from the paper before framing. The choice of materials to be used is quite important as are the type and colour of the ink **sumi** and paper. In certain abstract works the ink will be predetermined, though it is not a rule, and light coloured inks such as **shōenboku** that spread into a cloud around the character will often be used. Apart from paper, silk and gold are regularly used. One must possess great confidence and a mastery of subject to attempt using silk because of its prohibitive cost. Once written on, it cannot be used again. Gold, however, despite its reputation, is not as expensive as one might think (cf. **kokuji**). To write on gold, squares of gold foil are placed side by side on a smooth surface so that they overlap just a bit. If these are placed on a **byōbu** folding screen and hung on display the effect is outstanding. When writing on gold it is well to bear in mind the fact that the ink contrasts only weakly with the foil. In fact it is better to write with very thick **nōboku** ink as the surface of gold, shiny as it is, will often repel thin ink. The brilliance of gold may furthermore overpower intended subtleties in the work. The factor that makes such work relatively inexpensive is knowledge that mistakes can always be wiped off gold.

Tenkoku Carving Seals

If a seal is to be exhibited as a work in itself rather than as part of a larger work, it will normally be centered near the top of a piece of paper of A4 dimensions (210mm x 300mm although other paper **kami** can be used) or thereabouts. The contents of the characters on the seal will be written below the seal so viewers can understand it. Such works will usually be carved in old calligraphic styles such as antique **kobun**, seal **tensho** or occasionally the scribe's **reisho**. Other exotic scripts meant particularly for seal carving are called generically **zattaisho** and include scripts of varying form, include "flying white" **hihaku**, "steel wire" and "fence" scripts. Finally either the name of the person who wrote the poem or the name of the artist who carved the seal or both are included.

刻

Kokuji Carved calligraphy

To me a piece of carved calligraphy is the hardest to execute because it is really three works in one. Not only must the written characters be first class, but carving techniques must also be well developed. On top of this one must create a work that is appealing to the eye. A seal and a dedication are also often included at the written stage and carved together with the other elements of the work.

General Remarks

Never expect to manage a perfect work on the first attempt. Ogishi only began to experience satisfaction with his work at the age of fifty and that after a life of relentless practice. Many calligraphers will write the same piece fifty to a hundred or more times using the best of materials, rare inks and expensive papers each time. Small wonder works of calligraphy are so expensive to buy. Do not be defeated though. After a good many earnest attempts there will be one that stands out from among the rest, good not only from a technical standpoint, but one that also brims with the feeling you had hoped to express.

This effect may be more difficult to manage in seal carving since if one makes a mistake or becomes dissatisfied with this work for some reason or other, the stone must be cut down, sanded smooth and started again. In carved calligraphy this obstacle can be avoided to some extent by writing the original on less expensive paper at the outset or making slight amendments in the tracing. The expense will be incurred in the wood and other materials.

Jō Emotion

It is difficult to express enough the importance of blending an emotional state and calligraphy together in a work. A Chinese proverb puts it succinctly: "If the heart is right, the handwriting will be correct." A work without feeling may as well be a street sign. Sign painters do not necessarily make the best calligraphers and that is why shops with a reputation to maintain will often commission a famous calligrapher to write their shop sign.

In the hurried, full of pressures world we live in it is often a problem to adjust the feelings of the moment to match the content of our calligraphy. For this I find

15

music invaluable. To engender a sad, lonely feeling I play Sibelius' **Valse Triste.** To reproduce a powerful, majestic feeling there is Bruckner's **9th Symphony.** Dixieland Jazz played loudly goes far toward giving me a happy, joyful feeling. You no doubt have musical pieces of your own of which you are particularly fond that will produce differing emotional states in yourself. I would not, however, recommend using a radio because commentary tends to divert the attention and succeeds only in distracting one from the task at hand. Music will win over your heart and your calligraphy will improve by leaps and bounds. As for myself, when planning a work I look for a poem that is one, the right length for the composition I am planning, two, has a content I find enjoyable and three, has characters of a sort that will either make for an attractive work or be challenging. Then I look for the piece of music that I think has similar qualities: the spiritual tone (sadness, happiness, loneliness) that I hope to instill in the work. If you do the same, first put your music on to create the state of mind you require and only then approach your paper. Emotion will flow from your soul, down your arm, through your brush and on to the paper. By now you will have had much practice at making the brush an extension of your arm.

Actual Realities of
Planning Your Work

First of all decide upon the poem, select your materials and style of character and then try a few lines on **hanshi** paper to determine whether a vertical or horizontal layout suits the size and shape of the work and just how the characters might best be arranged. Then try your composition on paper the same size as your projected work, but of a cheaper quality. Give some thought too as to whether there will be a **rakkan** dedication or not and where seals might be placed. Position of the seal will normally be symbolized by drawing a little square on the paper. Once the plan is set, get on with the writing of your work.

Hyōgu Backing

The tools: 1) A smooth surfaced, solid table

2) A drying board of either smooth plywood or veneer

3) A long ruler

4) A piece of backing paper the same quality as your work, but slightly thicker and larger in area

5) Another piece like (4)

6) A brush for glue, **noribake**

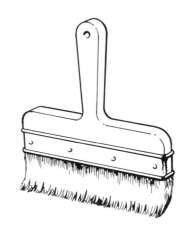

7) A soft, clean brush for water, **mizubake**

8) A brush with hard bristles, **shirobake**

9) Glue, a thin cow gum or any water based glue is good. Specialists use a glue called **shōfu**. Boiled wheatflour is sometimes used as well.

10) Several old sheets of newsprint.

The method:

Firstly if the work is not your own, it is important to know whether the work to be backed was written using a proper inkstick **sumi** or with prepared ink **bokujū**. **Sumi** is made of soot and a natural glue called either **nikawa** or **funori**. Japanese make this glue from cows' or horses' bones and the Chinese from whale bone. Japanese ink sets more firmly than Chinese which means it is less likely to bleed when dampened. **Bokujū** has improved so much recently that better brands run hardly at all. Nevertheless here is a note of the chances of their running: Ordinary prepared inks, 50%; special or very thick **bokujū**, 10%; Chinese inksticks, 5-10% and Japanese

inksticks, less than 5%. If you have a work done by a specialist, he will warn you of the possibility of its running and may even go so far as to taste the **sumi** with the tip of his tongue to ascertain its origin.

Avoid using Western paper and Oriental papers together as Western paper is much less absorbent. Prepare sufficient sheets of thin backing paper before starting. If the work is large or is made of several pieces of paper, backing papers must be joined ahead of time into a suitable length (see illustration). Take piece A and draw a line with the ruler and water brush as shown. Then gently pull off the piece marked "X". The tear will be straight, but some fibres of the paper will be left sticking out. These the Japanese call **teashi**, limbs.

Now do the same for piece B. Join pieces of newsprint and place them on your working surface. They ought to extend to an area larger than the size of your work.

Dry newsprint is a must because if the ink on the sheets is still fresh, it will transfer to the backing on your work. Cover the backing paper with a thin coat of glue, about the same consistency as thin cream. If the work to be backed is quite large, place the backing on a single sheet at a time and then add glue to them.

Get the first sheet in place and then proceed to the second. Lift the pieces with the ruler (see illustration). See that the **teashi** hang downwards and be very careful to join the ends of the papers together in a way that they interlock, not overlap.

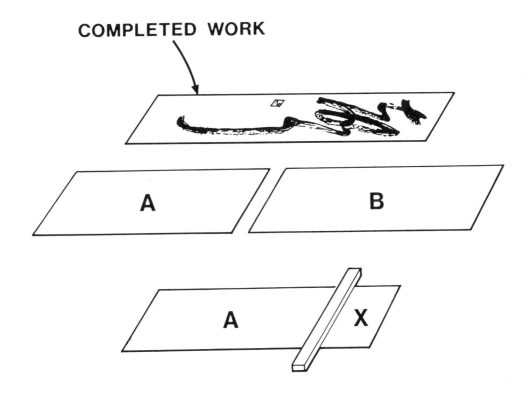

COMPLETED WORK

18

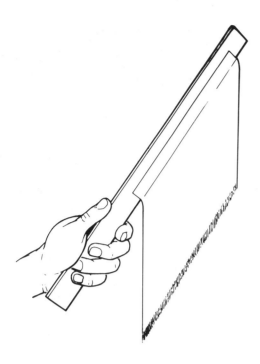

Brush all the wrinkles flat, but avoid brushing around the join itself. This spot is best pressed flat with the ruler. Make sure that both pieces of paper are either rough side up or down, not one of each. Dampen the work from behind slightly so that wrinkles are removed and place it on the prepared backing sheets.

Go over the front of the work with a soft, dry brush working out from the center to ensure even contact with the backing and removal of any air pockets. The midway point in the process is pictured at right. Now be certain there is sufficient glue around the border at Z of a slightly thicker mixture.

Lift corners at **D** and **E** and transfer everything to the drying board which will have been propped earlier against a wall. Brush the entire picture with the hard bristled

brush, remove the newspaper and brush out from the center once more. Any stubborn air pockets still remaining may be removed by pricking them with a pin. A trick of the trade is to lift up the edge of the **heragami** backing up carefully at this point and blow a little air in between the work and the drying board. This helps it dry quicker. The best quality backings are done with very fine backing paper before repeating the entire process using thicker paper or perhaps silk as in the case of **jōfuku.** Leave this to dry for a day or two and then remove carefully from the board. Never cut the paper as this will mar the drying board, but slip the blade of a knife under the edge of the paper instead and lift it off. One further tip.

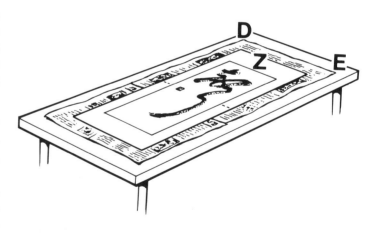

If you are doing the backing yourself, do not press your seal to the work until backing is complete. This is because the ink for the seal is oil based and handling it without smudging is a very

19

difficult procedure for an amateur. Ignore anyone who says it cannot be done because the paper will then be embossed. If the seal is pressed on a fairly hard surface, it makes no difference. The paper is only a millimeter thick.

Points to be careful about:

1) Take care to brush from the center and keep your brush away from the glue at the border because it may be transferred to your work. If you do get a little dab on it it will not harm it, but is just faintly visible.

2) Use only the best brushes as any other will tend to leave stray hairs on the work which do not become evident until later, when it is too late to make corrections. It is possible to remove them carefully with a pin, but a slip may result in a puncture in the work.

3) Holes in a picture. More vigorous calligraphers will occasionally tear the paper they work on either because they have begun with too much ink or have applied too much pressure at a point where several strokes coincide. You will notice that the paper that has been torn from the hole has been crumpled up at the edge of the hole. This can be smoothed back over the hole to restore the completeness of the paper. If the paper was torn away with the sweep of the brush, an attempt may be made to replace the fragment, but that is nothing to worry too much about. This is often evident in pictures at exhibitions. It can also be seen in my work "kuri" if you look closely. If the middle of the hole is missing fashion a simple patch for it so the ends will not tuck under. The thinnest possible paper is best. Cut it so that it is just a fraction larger than the hole, and fray the edges of the patch so no ridge builds up. Then open out the hole from the reverse side, dampen, align the grains of the paper, apply the patch, paste and lay flat before continuing with the process.

4) In a large of work of several pieces of paper inevitably there are slight overlaps. Try nevertheless to avoid any similar overlapping on the backing paper since it will simply make the join all the more evident.

The term **hyōgu** refers to the same process used to make the hanging scroll works called **kakejiku**, but the process for this sort of a work is exceedingly difficult and will require a professional. The process described above is a simple **hyōgu** described by the Japanese as **urauchi**, lining.

Framing and Exhibiting

Sho <u>Calligraphic</u> <u>Works</u>

Many works are often of a standard size, for instance the **shikishi** 24cm x 27cm, and attractive frames of dark blue or burgundy mountings with natural or black lacquer frames are available in Japan for these. As **shikishi** are already on a stiffened board, they can be slipped in and out of the frame and changed according to season. Generally calligraphy is done on thin paper however, and this must be backed in the way explained above to give it strength and remove wrinkles.

Several types of frame are available including steel and wood in various shapes, colours and lacquered hues. Simple black or brown wood or plain steel frames less any embellishment are preferable. The interior of the frame may be lined with silk or perhaps a material that has proper substance or with an attractive weave like hemp or jute. Colours ought to be positive like light blues, burgundies, russets, navy and so on. Avoid busy patterns like tweeds or checks-anything that will detract from the subject.

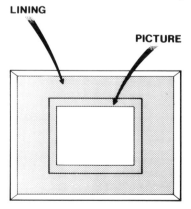

Sometimes not all of the interior of the frame will be lined and the middle simply cut out for economy. Edges of the work should then be trimmed with a large paper cutter instead of scissors and then glued lightly in place. Use perspex instead of glass if you can. It may be more expensive, but it is lighter and will not break even if it does scratch. There should be a slight gap of a centimeter or two between the glass or perspex and the work.

It is possible to hire frames, but it should be remembered that each time a picture is put into and removed from a frame the backing gets a little thinner at the edges and there is a danger the picture might be ripped. Transfers can only be done twice or so before a permanent frame must be found. In extreme cases backing can be done once more, but this is risky work. See illustration for several examples of mounting.

Notice that the boundaries at the top and bottom are in many cases elongated. Smaller works, seal carving for example, are often raised within a deep frame.

It is possible to obtain "reusable" hanging scrolls. The borders are already made up and one has but to attach his work. The disadvantage here, however, is that since it is cheap, it looks cheap and half done so it can be a detriment to a good work. I have often been asked why there are two strips of material hanging down from the top of these hanging

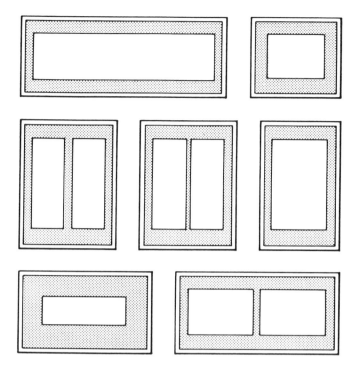

scrolls and the story is this. These attachments date from days in old China when people were fond of holding parties outdoors in the summer. They would sing songs, recite poems and perhaps practise a bit of calligraphy-to commemorate the occasion much like we might take a photograph nowadays. To keep birds away they hung ribbons in the trees and the ribbons on the scrolls originated from that custom. Japanese call them "tsubame odokashi", scarecrows. The work is mounted on material **donsu** brocade which has been backed with paper. The material may have a Chinesey pattern and if gold is interwoven in it it will be called **Kinran donsu.** Just at the top and bottom of the work there are often strips of material in a contrasting colour **ichimon**ji "the figure one" the top will be slightly wider than the bottom at a ratio of 3:2.

Two **fūchin** weights are suspended from the bar at the bottom of these scrolls. Works that have been stored rolled up for a long time tend to remain curled so these weights straighten them out and also prevent their moving about in draughts as doors are opened and closed. The traditional place to hang a scrool is in the alcove **tokonoma** in the main room of Japanese homes. Here one's most treasured possessions are shown off. Lastly nearly all old forms of calligraphy come in a scroll form known as **makimono** or **kakejiku** and they come in boxes that are signed at the outside by the artist. Most Japanese collectors will not accept a piece of calligraphy at its apparent value without the original box.

Modern styles of mounting do away with side borders altogether. Of course works may also be just mounted on a board, but they get soiled in time by repeated handling and dust clings to the fibres in the paper. Still another attractive means of presenting one's work is as a folding screen, **byōbu.** This may be two or three panels, but always use

one already made as they are not as easy to construct as they look. They are particularly effective covered in gold foil.

Carved Calligraphy

This sort of work obviously need not be framed as framing tends to be expensive and will often detract from an elaborate work. Still, saying that, I think the pros may outweigh the cons for these reasons: **Kokuji**, carved calligraphy, is so detailed it is difficult to keep clean. Once framed, a work will often appear more finished and complete and smaller works will be given a proper bearing. In large exhibitions there may be a couple of hundred entrants in the carved calligraphy category alone and works are usually stacked against a wall someplace and shifted from place to place by students, so the risk to your work is considerable if you expect to sell it at the end of the exhibition. Dents in gold leaf or the wood, chips,

scratches and knocked off bits are inevitable with even the most care, so a frame will protect the work. Works in excess of 70cm x 140cm need not be framed as they look and are too bulky.

The lining in these frames can be of coarser materials than for written calligraphy **sho** without any cheapening effect. Be certain the wood and the colour of the

lining contrast - light wood and a light lining look lost. Frames must furthermore be deeper set than otherwise might be necessary to accomodate three centimeters or more of wood. Some have resorted to the clever use of frames just for exhibitions and then switching the contents, but judging by recent exhibitions the life span of a frame is only a couple of years. A double frame will often set a work off well especially if the work is on thinner materials of a centimeter or less.

FRAMES　　　　**LINING**

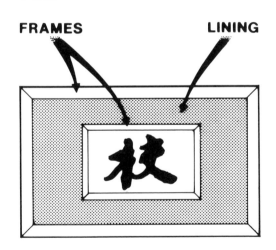

Exhibitions

In most group exhibitions one has no say as to where his work will be displayed and it may occasionally be someplace among three tiers as much as three to four meters above ground.

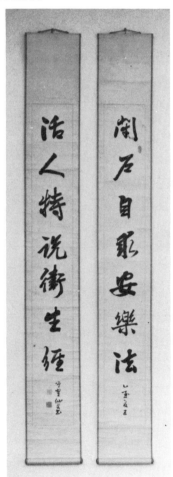

A work by Kusakabe Meikaku in the author's collection.

24

As to one man exhibitions, however, conditions are different. Being black and white, calligraphy goes with any room of nearly any colour design provided the frame does not clash with the scheme. In a one man exhibition, though, a plain wall, muted colours or unpatterned wallpapers are much to be preferred. Mix your styles up. Do not place all similar works side by side because people will then tend to make comparisons and busy themselves with criticism. A mixture will also add to the overall interest of the display. Keep the centres of your pictures just above eye level. It is a psychological fact that people think a work looks better if they have to look up slightly, shades of the better known art galleries no doubt. More people will be able to see it too if there is a crowd! Never cram your pictures together too tightly, if possible allow at least the length of the frame between adjacent works. Try also to place only one large picture on a wall with smaller ones at each side instead of two larger works in competition. Two large pieces look neither large nor impressive when placed side by side. Arrange the room or rooms so that people will progress through without having to double back and will enter and leave at the same point. Place a few chairs back to back in the middle of the room with a table graced by a flower arrangement. People will be able to enjoy the pictures at their leisure and small favors are not forgotten. Prices may be displayed on the frame, or with a label at the side with the title or number of the work, or separate handouts may be given to viewers. The important point is discretion since an exhibition is a show, not a market. As a work is sold affix a red tag to it or perhaps as is the custom in Japan, place a label **baiyakuzumi** with the name of the exhibition and the purchaser's name on the piece "sold".

If you intend to hold another exhibition in the future placing a guest book, **hōmeichō**, at the entrance for visitors to sign is useful. Cards may be sent to those who signed and it is probable sixty per cent of those who signed will turn up once more.

Do not sell straight from the walls, but wait until the exhibition is over. Do not promise to deliver too soon after the exhibition is finished either as if frames are rented, new ones will have to be ordered and that will take time.

Finally do not hang your pictures from an open grid system like scaffolding or the pictures will be visible from behind and that is not their best angle. Their illusion is dispelled; and a picture looks like a hole in the wall going through to infinity-but it would not seem so if seen from the back.

I mean that they cease to look worth the amount of money you might be asking for them.

Tenkoku Seal Carving

Tenkoku is a minor art closely associated with calligraphy and recently the collection of examples of this art has become as popular with fanciers as the gathering of **netsuke**, Japanese toggle ornaments. Seals are used in place of or in addition to an artist's signature, the idea being that while it is elementary to forge someone's signature, reproducing a handmade seal is extremely difficult.

In ancient times a seal represented authority issuing from an Emperor through to an official. Some of the most famous seals in Asia are the gold seal given to the king of Kan-no-Wa-no-Na, an ancient kingdom in Northern Kyushu, southernmost of the four main islands of Japan, and the jade seals that were symbolic of Chinese Emperors as early as 800 BC.

Nowadays seals are necessary in ordinary transactions such as negotiating bank cheques, signing contracts or on marriage certificates where the groom uses one with a predominantly white background called the **yang** and the bride a largely red background called the **yin**.

Important matters in ancient times were written on **mokkan**, strips of bamboo bundled together with string knotted and stopped with a lump of clay impressed with a seal. Calligraphy and painting flourished with the widespread use of paper that occurred about 200 AD. Seals were then used as a signature at the end of poems or paintings and subsequently pressed on to works either as a sign of one's appreciation or as proof of ownership. This idea was particularly popular during the T'ang and Sung Dynasties. The art treasures of these period are almost completely covered with impressions of the seals added over the centuries.

Personal seals engraved with one's name were commonly used as early as the Warring States and Chin Dynasty, 403-221 BC. Then people carved salutary sayings on them, wore them as amulets and were even buried wearing them. The remarks on these seals evolved into mottoes and elegant poems. Official seals in early times were cast mainly in bronze, but gold, silver, agate and jade (exclusively for Emperors) were also used now and then. Today more common materials for these objects include: ivory, bone, crystal, amber, boxwood, soapstone or plastic. The red ink used with these seals, or more appropriately vermillion, was made of cinnabar and seed oils, but now derives from a compound of mercury. Japanese call this **shuniku** or **inniku.**

The seals used in Japanese society today are known by the collective term, **inkan.** There are **jitsuin**, one's registered personal seal for official business. Any transaction requires a

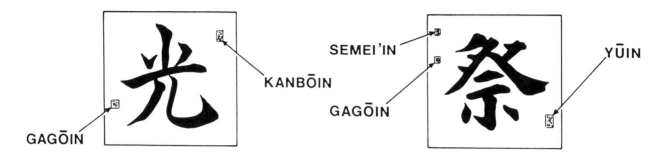

GAGŌIN · KANBŌIN · SEMEI'IN · GAGŌIN · YŪIN

document from the local ward office testifying as to the validity of this seal called an **inkan shōmeisho.** There are also **shaban,** registered seals of companies and **teisei'in,** tiny seals used for certifying corrections made on official documents. People often use the word **hanko** when they mean inkan. The difference between the two instruments is slight; normally a **hanko** is a mass produced seal used in place of the signature where anything is acceptable. It is not acceptable on official documents or with cheques.

In calligraphy a seal, often referred to as just an **in,** will be classified in four ways: one's real name, surname and given name, carved on a seal to be placed generally at the top or bottom of the left side of a work is called a **seimei'in;** one's pen name **gō** (see section on **ateji**) placed also on the left if used alone or below the **seimei'in** if used with that seal, is known as a **gagō'in.** When the two seals are used conjunctively the one on top will display the background in red, **hakubun** and the other in white, **shubun** (see below). Seals carved with short poems, riddles, maxims and so on are called either **kambō'in** or **yū'in.** They differ in one point though; the **kambō'in** is placed at the top right and is

the more often used of the two while a **yū'in** will be placed at the bottom right. They are not used together or on works done in **kana,** the Japanese syllabary.

Seals are normally square shaped and range anything from one centimeter to ten centimeters square. Rectangular, round or seals in the shape of a gourd or other everyday object are also used. Besides an inscription, seals may sometimes be highly decorated and have dedications or the carver's name on the side. In rare cases a seal will be carved at both ends or perhaps on several of its facets.

The engraver's art is much more restricted than that of the calligrapher as he has little choice of materials and his characters, be they long and thin, must fit into a small space. The scripts he most often employs are known as the Smaller and Greater Seal Scripts, but for seals which you choose to carve for yourself most styles may be used including a hybrid **zattaisho.** When the characters are carved, that is engraved, from stone the resulting work is known as **hakubun** so that the impression leaves the white. The Chinese refer to it as a **yin** seal. When the characters are left

27

in relief it is a **shubun** or **yang** seal.

To do a seal carving of your own you need to prepare the following things: first of all the stone, either alabaster or soapstone. Both are soft and easier to carve than box wood. The surface you plan to carve should be smooth and ought to be sanded with either a very fine grade of sandpaper if you are not using a stone especially prepared for this purpose. If no stone is available, some soft variety of wood should be used.

The tool used in seal carving is often referred to as a **teppitsu**, literally "iron brush" and stems from the philosophy that incisions should be made only once with no touching up, like characters are to be written with brushes. This is all very well in theory, but in practice this is very hard to do. For this work a small chisel or knife will serve very well.

The ink **inniku** is sold already made up in little containers. For works of calligraphy you are advised to purchase the deepest vermillion you can find and by all means do avoid the orange-red that offices and banks use. The drawback is the better the colour, the higher the cost. Good **inniku** has the consistency of putty and comes with a little spoon for tidying the mixture up after use. Large seals will not fit into the dish so the **inniku** can be built up into a small mound using that selfsame spoon and thereafter applied to the large seal a corner at a time. Dishes for transferring the ink into before applying large seals are sold, but they are bothersome and expensive. If no such ink is available soaking gauze in poster paint will suffice.

You will need a small brush for tracing the lines of your seal design on the stone, black or red ink like teachers use, paper for trying the seal and transferring the design **insen** and **inshi**. Other equipment which may facilitate your work are a mirror, a clamp or vice for anchoring the stone while carving the seal and an old toothbrush. Later once your seal is completed and you are on the point of applying it to one of your works, you might do well to have purchased ahead of time an **inku**, the small set square placed beside the seal as it is being pressed on to the paper and held there after the seal has been moved away from the paper because should there not have been enough ink on the stone at the first impression it can once more be placed in exactly the same position until a satisfactory colour is achieved.

The next step in the process of seal carving is to choose an **inbun**, the contents of the seal you plan to carve. Once that is decided choose a character style and write out your work right to left. Writing them out a couple of times on a piece of paper as your rough copy, **inko**, will give you an idea of how they will fit into the space you have. Often the number of characters on the seal can be increased to better fit the needs of aesthetics by adding the ideogram which signifies

"seal" to the end of a **seimei'in** or **gagō'in.** The result will read something like "Peter Smith's seal."

How to carve the seal

There are four principal ways to transfer the seal design from paper to the face of the stone and they follow here in preferred order: first using a mirror coat the stone with red ink, prop the mirror up so that it faces you, put your design next to the mirror and then point the face of the seal at the mirror, copy the design as you see it in black ink. The difficult bit is that it is no mean trick to write with your brush facing the wrong way.

The next method is to press the stone into a piece of paper held in the palm of your hand so that the outline of its shape is imprinted on the paper. Write over this in thick ink and press the stone onto the design before the ink has had time to dry. The drawback with this method is that sometimes not all the design is transferred in the process. The third means is to write the characters backwards in black ink directly on the reddened surface. This is difficult to do accurately or even aesthetically. Lastly there is the even harder task of carving the design directly on to the stone.

Remember that the surface must be sanded flat as

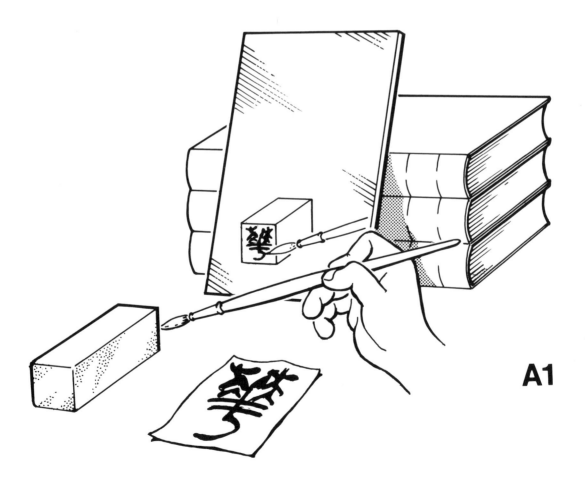

A1

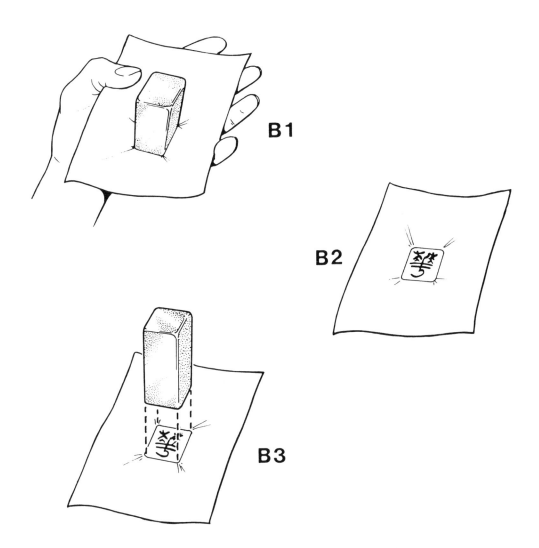

B1

B2

B3

possible before starting. To avoid rounding the corners move the stone about the sandpaper in a circular motion. Take care also when carving the **shubun** seal, to leave a border around the characters otherwise the work will be lost because it will appear to float about the paper. Do not attempt to be too tidy; jagged lines, chipped corners and edges add to the feeling of antiquity and give the work greater distinction. If you make a mistake, cut off the top, sand it down and start over.

When impressing the seal on silk or paper, press the stone firmly with your weight centered above so that it does not slip, hold it there for a few moments so all the ink will be absorbed (this is the time to move the set square into place) and lift off vertically. Be sure to put some paper underneath, an old newspaper perhaps, because it helps to show all the detail of the seal. Another way to bring out all the detail is to move the work with the seal still in place slightly toward you over a smooth surface. Clean the seal now and then with the toothbrush, either wrap it up or place it in a seal box because too many chips are not desirable. If sometime in an

emergency you have no ink and must impress your seal, you can breathe on it and press it once more without applying ink as the "oil" in the remaining dry ink is revived when it is warmed. This is more for the small **hanko** than an **inkan** though.

The position of a seal is vital, but it is not something that can be taught

feels too "empty." Like other aspects of calligraphy positioning seals is a feeling that is learnt through experience. Often the use of a smaller seal about a centimeter square is called for and if you have no seal that small you can "arrange" an impression of that size by covering your usual two centimeter seal with paper so that only half of it

or even satisfactorily explained. Obviously not all seals (**seimei, gagō, yū** or **kambō**) are used simultaneously, but normally either a **seimei** or **gagō** will be used, as this tells people who did the work. The positioning of a seal balances a work; if it is too low the work will seem to droop to the left; that is why the **kambō'in** is put in that top right corner, when it

shows. Apply the ink before covering!

Wooden **hanko** seals and **inkan** on occasion have a mark on one side to assist the user in finding the top side. Do not put one on the seals you make because it indicates you do not know which side is up because you did not make it. A quick glance at the surface should set you right.

31

Famous calligraphers and by association seal carvers will publish singly or by groups impressions of the seals they have made in small books called **inpu.** As they all tend to have had dozens, this document is of inestimable help in ascertaining the authenticity of any work.

Characters used in **seimei'in** or **gagō'in** are obviously people's names. If a calligrapher happens not to be Oriental this seal can be done in one of the Japanese **kana** syllabary although for seals it is infinitely more pleasing to use a phonetic equivalent for one's name or **ateji.** Let me tell you how I went about deciding what to put on one of my **kambō'in** seals. I looked up by birthday and found that I shared it with John Steinbeck, Henry Wadsworth Longfellow and Elizabeth Taylor so choosing the most venerable of that

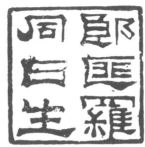

company,Longfellow, I carved the inscription "Ran Fe Ro Do Jitsu Sei", born on the same day as Longfellow.

If you carve seals as a work to be exhibited in their own right, you will normally carve a seal larger than average, about 8 or 10 centimeters square. The number of characters you use is open; just because the stone is bigger does not mean you must carve more. On the left of the framed impression write either the name of the author whose work you used or just your name. There is no need to follow this up with another seal.

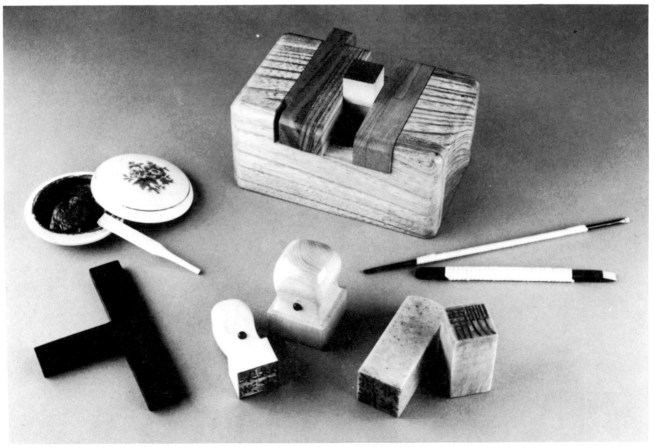

Kokuji Carved Calligraphy

By carved calligraphy I mean work that is first written on paper, traced and finally carved from a piece of wood. I personally find carved calligraphy in many ways harder than calligraphy on paper because firstly it has to be a forceful enough work to be successfully carved, secondly it must be carved accurately and powerfully and lastly it should be aesthetically pleasing and harmonious-three times the trouble! With this said though I must admit the finished work is very satisfying. It has a real depth and a substantial quality to it that make it the centre piece of a home. Let me proceed to tell you how to go about doing one of these pieces.

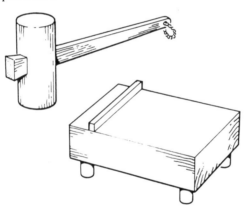

First there are the tools: **kizuchi**, a wooden mallet, **nomi**, a graduated set of chisels, 0.3, 0.6, 0.9, 1.2, 1.5, 3.0 and 4.2 centimeters, a working surface, the **dai** in the illustration below, a carpenter's square, **kanejyaku**, (The word **kanejyaku** comes from the term for a metal rule that builders of ancient Japan used to measure feet **shaku** and

inches **sun.**) This carpenter square is fashioned into a permanent right angle. The wood to be carved is called **ita.**

The best chisels have metal rings around the top. As you bang on it, the ring is driven down the wooden handle to a point where it holds the piece of wood in a very tight grip and prevents splintering. Refrain from holding the blade or touching the metal ring on the handle as this gives rust a start.

First an outline must be made of the work to be carved. Get a piece of the thinnest paper you can find and then make up some ink. It must be sumi because any other ink will run once the paper is glued to the wood. Place the paper atop the work and begin tracing. It is not necessary to copy every minute bit of

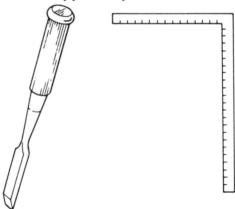

the detail; remember you must be able to carve these lines so do not make them too fine and apart from touching up your tracing, **kagoji** it is sometimes necessary to bring certain aspects of your work "to life." For example, the hook made by a few wisps of brush hair may lead to nothing. If, however, one were to add a slight receiving hook, then the stroke would be

strengthened and an invisible bond created between the two which earlier did not even appear to exist.

When choosing the wood it is best to select a quality wood such as White Cedar or Walnut. Never use soft woods as they splinter easily and finish poorly. The points to watch for in a piece of wood are that it is neither too hard nor so soft that your fingernail will leave a mark in it. It must not be so dry that it splinters.

Avoid pieces with obvious knots because many a good chisel has fallen to those. Finally do not use wood that has been cut from near the surface of the tree as the wood next to the bark is often of a much lighter shade than the surrounding wood.

Having decided on the piece of wood, cut it to shape and then sand it until the sheen of the wood is fit for a dining room table. In calligraphic carving only the outer surface, **omote** is to be used. A tree is cut in half before it is divided into planks and the side toward the pith differs from the side facing the bark.

How do you tell? Study the piece of wood from the top and along its curves. The convex side of those curves will point to the outside. Wood carved on this side has less tendency to crack. Lastly, if you are carving up and down rather than sideways, see that the grain curves inwards toward to the top because that will mean it is pointed in the correct direction. Make certain after planing and sanding, that your wood is at least 2.5 to 3 centimeters thick.

Next glue your tracing to the wood using a soluble glue. This is done by putting the tracing down on to the wood and placing weights at each end to hold the paper in position. Lift one of the weights from the tracing and apply a thin solution of the glue directly to the wood beneath with a large, clean brush just where you want the tracing to stay. Using a second brush brush the tracing to remove any air bubbles that might remain by working out from the center. Then remove the

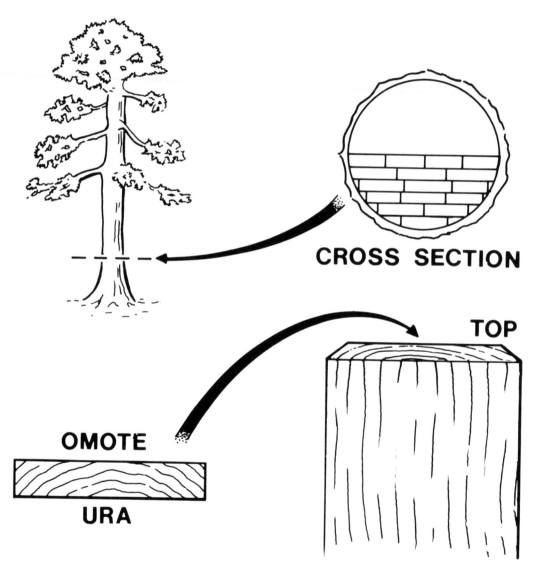

CROSS SECTION

TOP

OMOTE

URA

second weight and repeat the process at the other end. Leave this at least a day so it all dries thoroughly.

There are only two ways to complete a carving in the wood, convex or concave. Work done in relief is called **totsubori** and when the characters have been carved into the wood, it is called **ōbori**. If anything the easier and quicker of the two to carve is **ōbori**, but the **totsubori** is the more impressive. At any rate you must choose. If you decide on **totsubori**, the first incisions will be made about two millimeters outside the line around the traced image making sure the flat side of your chisel is always facing the character. If you had decided to work in **ōbori**, however, incise on the inside, two millimeters away from your line and face the flat of your chisel to the outside. If you think you might become confused as to which side is inside and which out, lightly pencil out the parts.

Always carve, wherever possible, with the grain, not against it because if the wood has dried out it can be hazardous carving otherwise. Deep splinters or cracks might occur in your wood.

Carving methods:
a) Make the first incision (2 mm away from the pencil line) with a single stroke that cuts at least a centimeter deep into the wood. The reason for this is that with this force, the fibres of the wood are compressed hard quickly and it makes the finishing cut clean and sharp.

b) Next carve away or carve out, but be sure that the second stroke does not undercut the initial incision.

c) Cut the finishing move, **agari**, with force and decision with a sharp chisel and follow the lines of the tracing accurately.

d) Finally cut the clearing stroke so that it coincides with the base of the **agari**. This applies to either concave carving, **ōbori**, or **totsubori**, convex carving.

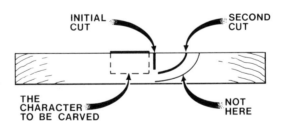

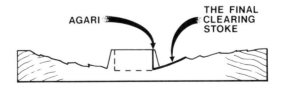

36

Ōbori:

With this sort of carving avoid cutting all the way in to the side or making hills in your valleys as paint will run to the lowest point when it is applied. Cut the bottoms flat and to a depth of at least a centimeter. Good effects can be created by carving in the standard stroke order; that is to say, a trench within a trench, first strokes overcarved. e.g. **kusa kanmuri.**

1) The scallop, often referred to in Japan as **Kamakura bori,** is derived from that popular style of woodcarving. Try not to leave any ridges or plateaux. Carve them away.

2) The wave **nami.** Do not allow this pattern to become assymetrical either along the width of the wave or at the point where the wave crests.

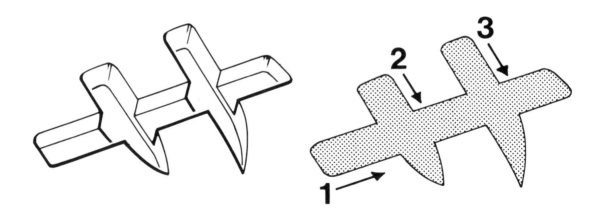

Totsubori:

Give the background some type of texture, the choice is individual and the varieties several, but the following are the most popular:

3) The check, **chekku.** Cut each square in a different direction if possible.

When the work has been carved, there are many options possible for "decoration." As a general rule, **totsubori**

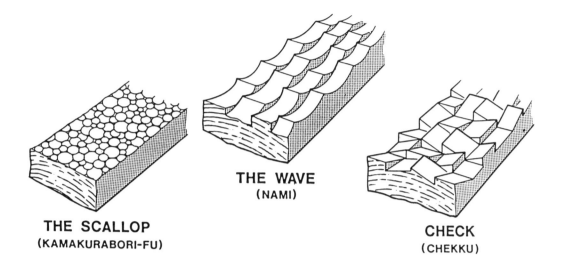

THE SCALLOP
(KAMAKURABORI-FU)

THE WAVE
(NAMI)

CHECK
(CHEKKU)

characters are gilded and **ōbori** are painted. The paints used are traditional Japanese ones and are used normally in the Japanese form of Western paintings called **Nihonga.** They come in a powder form and are very expensive; this is because they are made of pulverized semi-precious stones such as onyx or agate.

My experience has been that normal matt acrylic paints work well and are especially easy to handle in spite of the fact that they must be mixed to achieve characteristic Japanese hues. For hints on what Japanese colours look like thumb through a book on **Nihonga.** The most popular colours are green, dark blue and white. Another advantage of acrylics is that being thicker it is not absorbed as deeply into the grain of the wood and spillage or mistakes are easily removed.

Be sure to paint the "walls" of the carved character carefully; many people leave the remains of their tracing on the surroun-

ding wood while painting in the carved portions to protect against accidents, but I do not think this is necessary if caution is employed.

A third benefit of acrylic is that when wiping off the tracing with a wet sponge no harm is done should water splash on to the paint in the carved area. Franky I believe that it is very difficult to distinguish between the real thing and acrylic even though experts say they can tell the difference. One loses no marks for using it in exhibitions though, that is certain.

Tracing must include the **inkan** and **rakkan** if there are any because these will be carved also. Be certain the balance of the characters in relation to the wood is fair. One thing to keep in mind is that a finished work will normally be displayed above eye level so the characters must be positioned slightly above horizontal center on the wood. This makes them appear lighter and not as though they are

38

about to tumble off. The overall feeling should be one of majesty.

Now the surrounding wood can be carved or stained. If the characters are either blue or green and dark themselves, it is probably best to leave the remaining wood natural. White characters can be left as they are or made more dramatic by staining the wood a dark red or brown. This is like **Kamakura bori** and either will do so long as the original grain is still visible. Two homemade stains are used in Japan, a) **shibu** made of juice squeezed from persimmons left to separate. The residue stains the wood a dark russet brown. b) The other stain is a mixture of the black and red inks refer- red to earlier, **sumi** and **shuboku**. This shade is especially effective when scalloping in the **Kamakura** style. Firstly stain with a deep red and then wipe over it after it has dried with a rag soaked in the **sumi-shuboku** mixture. This will leave the valleys dark and mountains light. Remember to stain the sides of your **ita** as well. This is the point where one realizes how important it is to buy a piece of wood with a grain all one colour because any wood with lighter bits in it will stain lighter on those corresponding parts.

Stain all the wood first when doing a **totsubori** work. Make sure to get well into all the nooks and cran- nies and then leave it to dry. Avail yourself of a good brush here (one whose hairs will definitely not come out) and apply a fine coat of oil based varnish to the faces of all

the characters. A good hint is to save one of your larger chips and varnish it at the same time. When the varnish is tacky, (feel the chip to know when this is), apply the foil.

There are three types of foil that are generally available in Japan: 24 ct. gold leaf, **kinpaku**, silver, **ginpaku**, or aluminium, **arumihaku** and all are 8 cm x 8 cm.

Aluminium foil is usually preferable to silver, as silver tarnishes even if it is varnished. I personally, however, find the silvery- blue-grey hue of tarnished silver equally attractive.

The foil squares are backed with paper and have a small paper edge to grasp. Even so they must be treated with the utmost care. They easily crease when you just look at them. Use tweezers where possible. Do not be too rough when you place it down, but try instead to place it down gently on to the tacky varnish. Make sure that the pieces of foil overlap and leave no hard to fill gaps. Using a stiff brush, stroke the paper side and lift it off carefully. Parts of the gold will have adhered to the varnish and parts will have remained on the paper backing. If large bits are left, try to use them somewhere else, if not either peel them off or catch them up on the brush and put them into a jam jar be- cause gold leaf can be used later.

It is advisable to wear a mask while doing this as the slightest errant breath or

sneeze could play havoc and gold leaf your entire room. Leave the foil to dry for a couple of days; the drying process will have slowed now since the layer or varnish is no longer exposed to the open air. Use your gold leafed wood chip as your guide.

When the foil is absolutely and unequivocally dry it can either be left as it stands or rubbed gently with the back of a spoon and/or varnished to bring it up to a high sheen. Use a soft brush to remove surplus leaf and keep that in your storage jar too. Initial varnishing is a critical moment for if hairs stick to the varnish or you inadvertently fingerprint your work, this is when they begin to show up and nothing much can be done about it. If varnish has dripped down the side of the character and gold stuck here to, it is possible to cut the place off and restain the area with a small brush.

One other effective finish is to paint the face of the characters in a deep vermillion gloss, let them dry and then varnish over the work in patches. When the gold leaf is removed, deep red seems to be pressing its way up through the gold.

Handling troublesome areas:

When carving **totsubori**, give the walls of the work a base, especially the fine lines, otherwise they are likely to break off.

When carving **ōbori**, the walls should be at least as half as deep as they are wide.

Glue bits chipped off or parts of undercut characters back on.

If you have undercut an area in **ōbori** and a piece of wood has been left partially raised, it is very difficult to remedy this in any neat way. Nevertheless try easing the wood up carefully enough to insert glue beneath and then tapping the bit lightly back in with a hammer. Be certain first to lay something like a pallet knife over the break so the wood will not be dented when you tap it.

If you are colouring the characters in an **ōbori** work with a traditional paint, a good preventative is to rub some walnut oil applied to linen or walnut nuts crushed in a linen handkerchief to the facing edges of the characters. The nut oils will prevent the surrounding wood from absorbing the paint and the oil itself will subsequently be absorbed into the wood with no trace. This may however, make staining quite difficult. Should paint run into the wood it can be removed fairly well with white spirits. Wipe in the direction of the grain towards the character.

IN THIS DIRECTION

If the wood breaks, tack it with a few hoop staples, at the back. .

At points where the line is quite fine, cut almost to the end, but not into it and leave the detail to be done later with a penknife or some other similar tool.

Caring for your chisels

You will need two whetstones, a medium and a fine. If you chip you chisel use the medium stone before the fine to smooth off the gap and then hone it with the fine stone. The walls of any carving, **ōbori** or **totsubori**, must be done with a single and

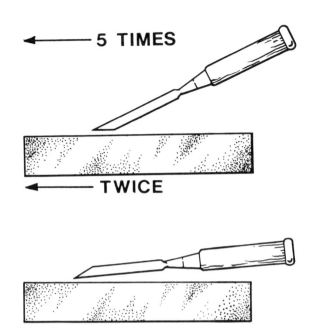

← 5 TIMES

← TWICE

forceful stroke. For this only the keenest chisel will do. Hone them regularly at a 5:2 ratio. The top drawing depicts the most ideal blade shape. A shape like that in the second drawing lifts up splinters with its corners. The third is not well suited to this task either, though for scalloping, a slightly rounder blade is helpful.

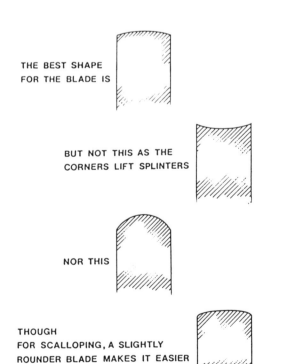

THE BEST SHAPE
FOR THE BLADE IS

BUT NOT THIS AS THE
CORNERS LIFT SPLINTERS

NOR THIS

THOUGH
FOR SCALLOPING, A SLIGHTLY
ROUNDER BLADE MAKES IT EASIER

Here are some points that judges look for in a good **kokuji** work: forceful, well written characters; correct characters, none miswritten **goji**; well coloured and presentable works free of sloppy details; well executed carving, straight walls or just a slight slope with definite strokes and tidy valleys on **ōbori** pieces; no splinters, chips, missing pieces or hair or fingerprints on the gold leaf on **totsubori**.

How to display:

For larger works framing may be unnecessary, but attaching a wire at the back is imperative. See the section on framing. Exercise care when putting in long screws lest they break through the front of the wood. This is especially so on **ōbori**. The best scheme is to put in a few short screws at either side to take up the strain.

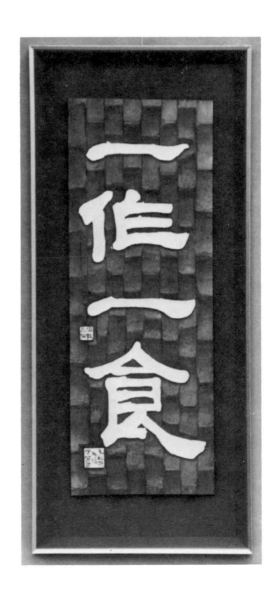

42

Takuhon, Rubbings

Takuhon is the name given to a method of taking copies from fine examples of writing that have been carved into stone; simply put it is a form of brass rubbing.

There are two ways of doing a **takuhon, shittaku**, the wet method and **kantaku**, the dry method. The tools include two sizes of brush, two or three puffed bags **tanpo**, ink and some water. Ready to use sets are available. When doing **shittaku**, the wet method, use only a stout Japanese made paper **washi**, clean the stone surface with brush and water, tape the paper so that it will cover all of the area you intend to rub, dampen the paper with a wet sponge and pat it gently with a clean brush (not the one that you used to clean the monument) so the paper will cling to the shape of the letters and meld gently into the depressions. This is where the quality of Japanese **washi** to reform itself comes in handy. Be certain to handle it with care, however, as it is nevertheless quite fragile. The ink must be applied when the paper has dried sufficiently; that is to say still damp, but not quite dry. Wet paper will look greyish, but begin to turn white again as it dries. Have a care because if the paper dries too much, it will separate from the stone and ink will have to be applied a second time. First make lots of thick **sumi** beforehand not on the spot because if you chance to spill it, it is awful to try to clean off. Have two ink pads

ready, A and B. Dab A into your ink and then gently tap A and B together. When sufficient ink has been tranferred over to B, begin to work on your paper with B. When the ink begins to thin out go back to A for more ink. Only occasionally dabbing A into the ink.

First define the characters and then outline the area you plan to rub. Build up the black by gradations; light grey to dark grey and last to black. This will require going over the same spot several times. If you put ink directly on the **washi**, the copy is black to be sure, but then so is the stone beneath. Besides that the white portion of the characters begin to lose their definition. Avoid hitting the stone with too much force. A softer and more consistent rhythm is preferable because use too much power and you may be tempted to give up your project midway through. If your picture is large in area, the paper may begin to dry out. In that case apply more water with gentle dabs of your sponge.

When you have finished, let the paper dry for a spell because if the paper has been saturated chances are it will begin to tear as you attempt to remove it. To transport it back home, roll it in another piece of paper so that it will dry without smearing. It is a good idea to leave a small area completely white so that when the work has dried you may apply your seal, have it backed and framed. You might consider doing it yourself in which case you will have to refer once more to the sec-

tions on backing and framing. Applying a seal is not absolutely necessary, but it does show who did the rubbing and to whom it belongs. Besides that it sets off the work nicely.

The **kantaku** dry process is the same as the foregoing wet method, but first you allow your paper to dry completely. Then you do not apply your **sumi** ink, but use one of several kinds of dry medium: **tsuriganezumi, sokutenboku** or **sekkaboku** soft gummy inksticks, a black wax crayon or conté. This makes for a somewhat inferior copy compared to the wet method, but if you happen to be on holiday or something and do not want the bother of lugging around all those heavy utensils, or just want a reference copy for your study, then it will do.

The stones which are the target of most of the rubbing are called **hi.** They record the deeds of famous men, historical facts, prayers or praise to God. As you study an inscription you may notice a larger set of characters enclosed at the top. This is called the **tengaku** and it gives the monument an element of design integrity. It is often written in seal script, but may occasionally be seen in one of the hybrid scripts like **hihaku,** flying white. The term for the inscription beneath is **hibun.** If the monument is square it will be referred to as a **tamaishi.**

Hyōsatsu Name Plates

Names plates are displayed at the side of the door or gate leading into homes. They are written either on plain wood or carved in cedar or the like. A nameplate should be about 20 cm x 9 cm x 3 cm. The problem with this is that the ink runs uncontrollably as soon as it is applied. The way around this is to first make the ink as thick as is practicable and then coat the **hyōsatsu** with a solution of polishing powder, **tonoko**, two parts powder to eight parts water and then start writing. Failing that try rubbing chalk all over the writing surface. Carved name plates are made the same way as normal works; in fact it is a very good idea to practice on something like this before tackling something larger and necessarily more expensive.

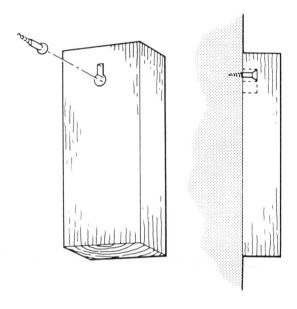

The only thing written on this is a person's name. The carver signs his work on the side.

To make a hook you need only drill or cut a squarish hole a centimeter in depth followed by a groove about half a centimeter deep as well as long. The width, however, will be less than the size of the head of a screw. When the name plate is placed over the screw and pulled down hard enough so the screw cuts into the grain of the wood, it is firmly attached and can only be removed by simultaneously pushing up and pulling forward.

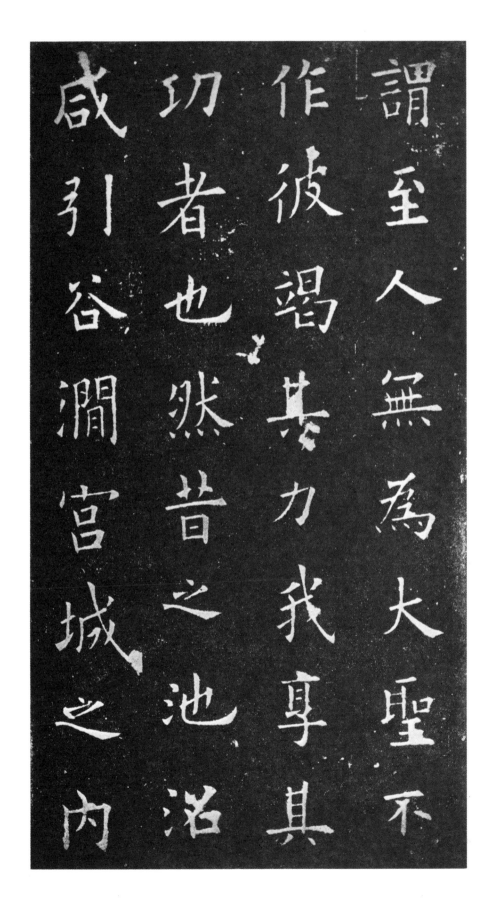

謂至人無為大聖不
作彼竭其力我享其
功者也然昔之池沼
咸引谷澗宮城之內

Kyūseikyū Kaisho

46

Tehon Explained

The characters given in the text have been especially chosen to illustrate these various lines and to develop the students ability with the brush.

The three styles that have been chosen are **kaisho**, which make use of the **Kyūseikyū reisen no mei** as a model text, **gyōsho** which make use of the opening passage from **Shūji shōgyōjo** and **hiragana**. The **kaisho** has been explained in some detail with sequence photographs showing how the brush is manipulated. The **gyōsho** will teach fluidity within the confines of the **kanji** and **hiragana** which in many respects is similar to **sōsho**, the grass script, is a challenge because of its simplicity. The **hiragana** has been given in the form of the **iroha** poem (cf. appendix).

Both **Kyūseikyū** and **Shūji shōgyōjo** are stylized examples, the all important part where the brush first touches the paper **shihitsu** is often elaborate, the **taku** sweeping to the south east is often overextended and the characters themselves may be elongated. In **Shūji shōgyōjo** especially there is the contrast in size between one character and the next and they are presented in the text as they are to be found in the original work. It is good practice to try writing them on **hansetsu** in two rows of fifteen or three rows of ten (the last empty space just right for your seal).

The **kaisho** has been given first to illustrate the principles of stroke order **kakijun** and centering the character within the box, **chūshin**, though the student may wish to attempt the hiragana, with its curved lines and fewer strokes, first. The texts are not given in the same order as the strokes tabled above so that the easier characters can be introduced first.

In the explanatory notes for the **kaisho** the **kakijun** has been given. Further details can be found in the appendix. A dictionary giving the stroke orders is also invaluable; see the bibliography. The **chūshin** is represented by the vertical red line dividing the box. This gives the centre which is more of a feeling rather than the mathematical centre, it is where if an axis were to be passed through the character, it would most likely find a balance, so in the case where the **taku** has been extended to the southeast, this may influence the overall balanace and therefore the **chūshin**.

The horizontal red line shows the angle at which horizontal lines have been written and acts as a reference. It also makes it easier for the beginner to proportion the character correctly according to the paper size as in the sequential photographs, it is often better to write slightly higher than the middle of the paper, this is also referred to in the section on exhibiting.

Characters **kanji** are made up of radicals (cf. appendix **kekkōhō**), but are also derived from fundamental strokes. There are several theories about the number and types of different strokes, some theories put it as few as eight (cf. appendix **Eiji Happō**) and others as many as seventy-two different strokes. The Japanese Cultural Affairs Agency has approved a table of twenty four as representing the standard strokes known as the **gakunenbetsu kanji haitōhyō** and the table shown below is similar in form.

1	2	3	4	5	6	7	8	9	10	11	12
一	ノ	亅	ノ	ヽ	ノ	コ	丨	ノ	＼	⌣	⊢

13	14	15	16	17	18	19	20	21	22	23	24
＜	＼	∟	丨	＜	➚	ノ	⌒	⁊	ヽ	⺀	∟

 1 ni 2 shita 3 roku

Ni is a simple character, but be sure to lift the ends of the strokes so they are not flat, the top line is not directly over the centre of the bottom line. For **shita** be careful to stop at the bottom of the vertical line and not pull it off. The two dots of **roku** are written differently; in the left the brush is placed down and drawn to the left, in the right the brush is just placed more firmly on the paper. This stoke is referred to as the bamboo stroke. See also the roku stroke in the appendix under Eiji Happō.

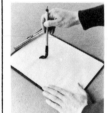 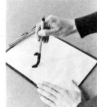 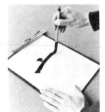 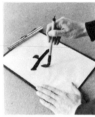 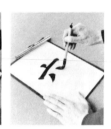

 1 ten 2 shi 3 kyū

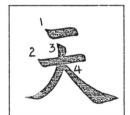 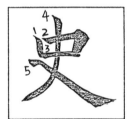 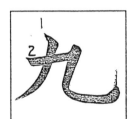

This vertical stroke is slightly different in each character. In **ten** the line is well balanced and the line seems to have been written slowly, in **shi** the line starts vertically with the point of the brush being pulled through the centre of the stroke- notice the tip ends with the point in the centre. In **kyū** the shihitsu, the all important first placing of the brush on the paper, is well pronounced and the line ends in a rougher manner.

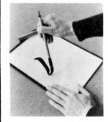 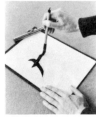 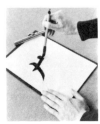 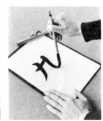 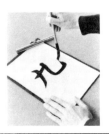

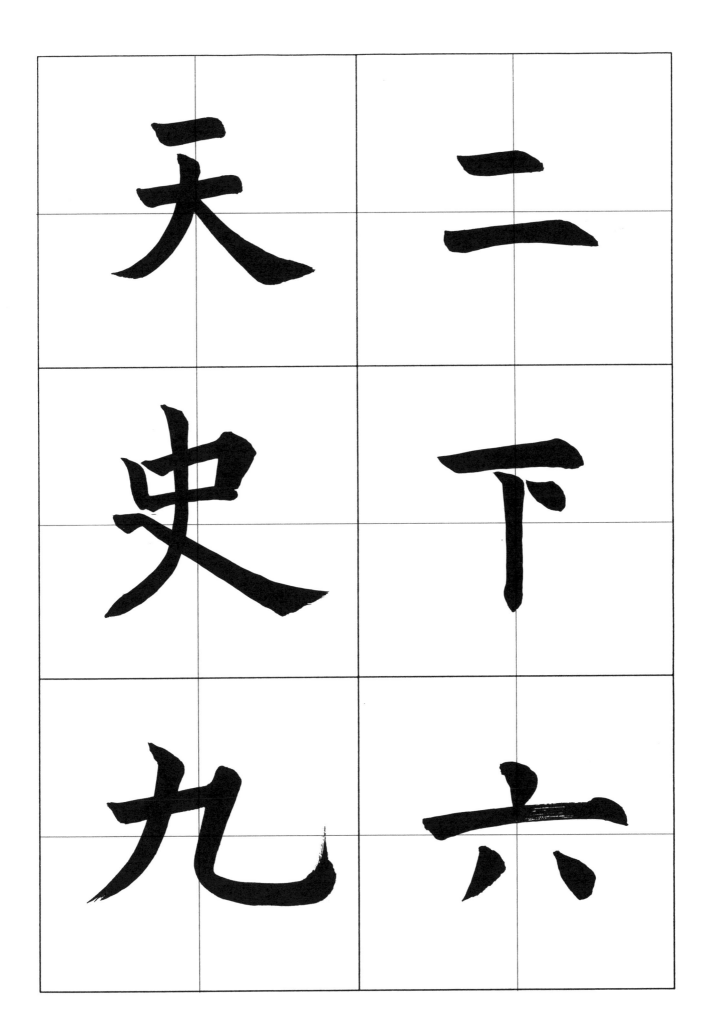

天 二

史 下

九 六

1 kuru　2 ri

3 higashi

This vertical stroke finishes with a small hook to the left. Notice in the photograph how the brush tip moves, the brush is not pulled, but rather the wrist does the work. In **rai** the fourth stroke starts rather far to the left, but is balanced by the seventh stroke. Be careful to keep the space between lines, 5, 6 and 7 equal in **ri**. In **higashi** the **chūshin** is further to the right than you would expect this ought to be because of the unusually long **taku**.

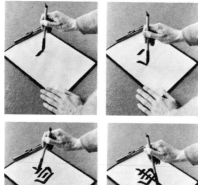

 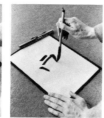

 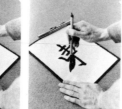

1 hito 2 rei 3 mono

To achieve the sweep in the first stroke of **hito** do not push the brush, but lead with the wrist. To achieve the fullness of the second stroke gradually increase pressure and then release while drawing off (see Eiji Happō). In **mono** avoid separating the **tsuchi** above (strokes 1,2,3) and the **hi** below (strokes 5-8), or conversely, closing the gap too much.

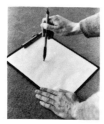 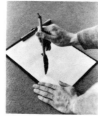 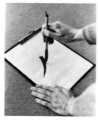 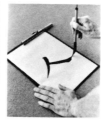

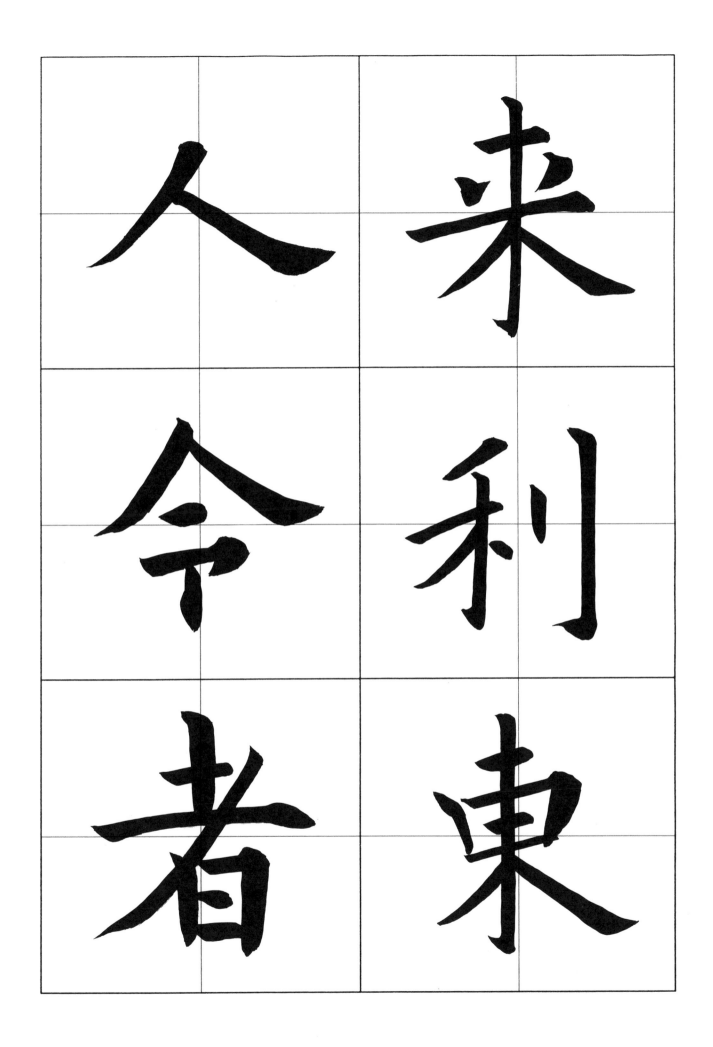

人　来

令　利

者　東

 1 moku 2 chi 3 kō

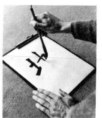 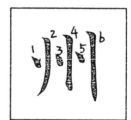

This ticking stroke is found in many radicals and here three are shown. The water radical in **moku** is delicate, but do not make it too small or the vertical in the **tsukuri** will look too long. The last stroke of **chi** should be carried off and continued through the air to give it necessary vitality.

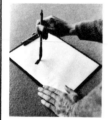 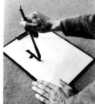 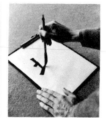 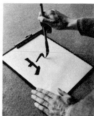 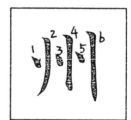

 1 tsuki 2 shū
3 atarashii

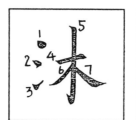 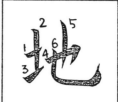 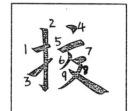

As was shown in earlier examples the vertical stroke is achieved by moving the wrist not the arm, in this case the stroke is brought off to the left near the end and here the arm helps. **Tsuki** should not be too long and thin nor should **shū** be too wide and stumpy. Notice how strokes six and twelve complement each other in **atarashii** to balance the character.

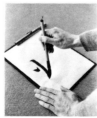 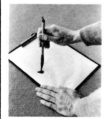 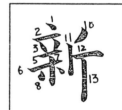

月 沐

州 地

新 拔

1 onaji 2 tadashi
 3 katai

 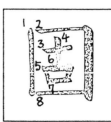

For **makigamae** (see Kekkōhō) the end of this stroke plays off to the left, however for **kunigamae** the line finishes dead and this can be seen in these examples. A second point is that the line is raised at the corner, as in the second stroke of **katai**. This is done by raising the brush and repositioning it. Avoid making the thickness of the four sides of **kunigamae** the same.

1 naka 2 mikado 3 kami

Unlike the previous vertical stroke this one is drawn off the end; keep the motion going through the air, however avoid exaggerating the tail. Notice how in **naka** the end of the vertical is rounder **kami** or **mikado** this is because the brush has been drawn off vertically rather than at a sharp angle to the table, which would emphasize the feeling of speed and would be more dramatic.

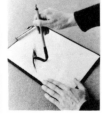 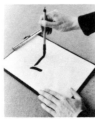 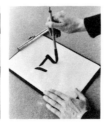 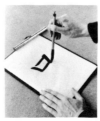 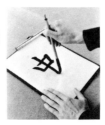

中 同

帝 但

神 固

 1 ko 2 ko 3 kyō

This stroke curving to the right is best achieved by moving the wrist round to the right in a circular movement at the same time increasing pressure towards the end of stroke and releasing quickly. Notice that the bottom part of **kyō** is in fact **ko**. The present form of this character is **kuchi** under the nabebuta (see Kekkōhō).

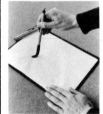 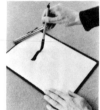 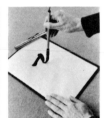 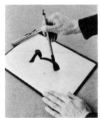 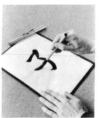 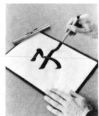

 1 dai 2 naru 3 uji

As in a stroke with a flicking tail at the end, the hand should follow the motion of the stroke through the air. This stroke has a dramatic sweeping motion. Avoid making it too flat. When writing **naru** open the inside up so the lines do not get cramped together. These characters should feel elegant and poised so do not use heavy, thick lines.

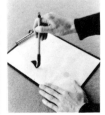 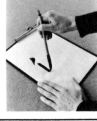 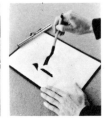 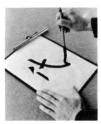 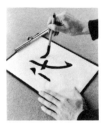

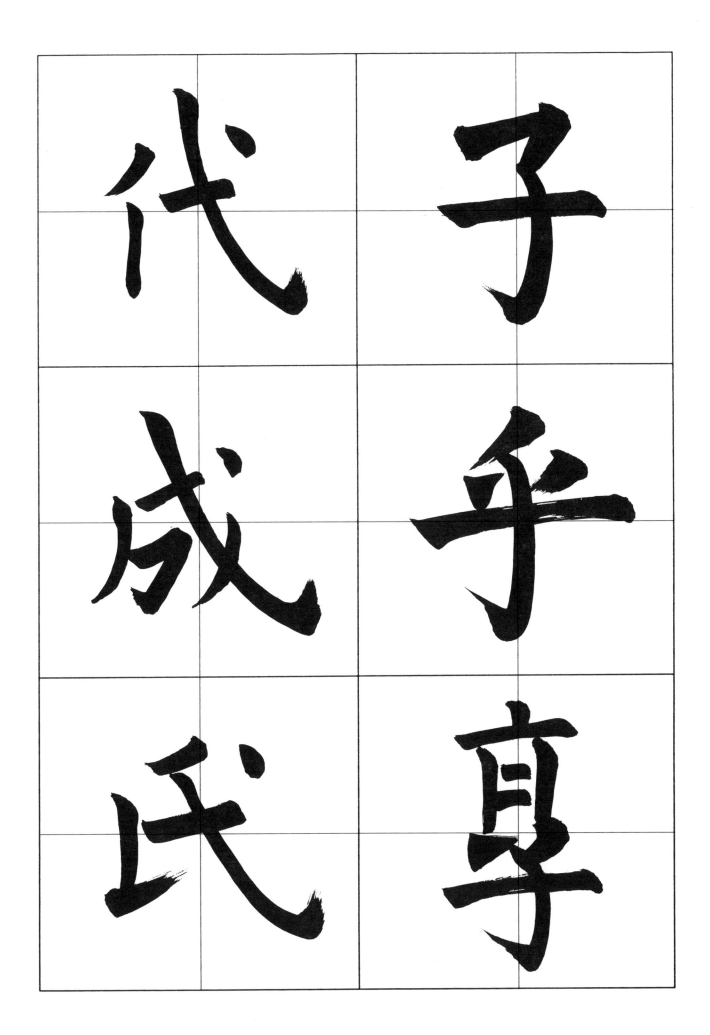

子	代
乎	成
尃	氏

 1 kokoro 2 nen 3 toku

 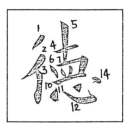

Bringing the brush across the page do not turn it round the last corner, but instead quickly push the brush into the top left corner, lifting it off the page as you do so. This stroke is nearly exclusively used for **kokoro**, so this is incorporated as a radical in **nen** and **toku**. The dots in **kokoro** should be in a line and when you see the **shōkeimoji** for **kokoro**, heart, you will understand how the dots represent the chambers of the heart.

 1 ōyake 2 saru 3 kumo

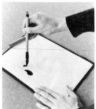 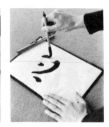

This corner stroke is like two strokes connected. Having brought the brush down to the bottom left, move it further to the left and increase the pressure before bringing the brush off to the right. The secret of this stroke is that it should be short and sharp as it it invariably leads into another stroke, and if it is extended to the right too much, will make the placing of the next stroke (number twelve in the case of **kumo**) difficult.

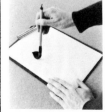 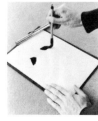 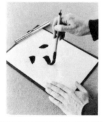 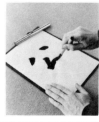 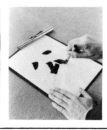

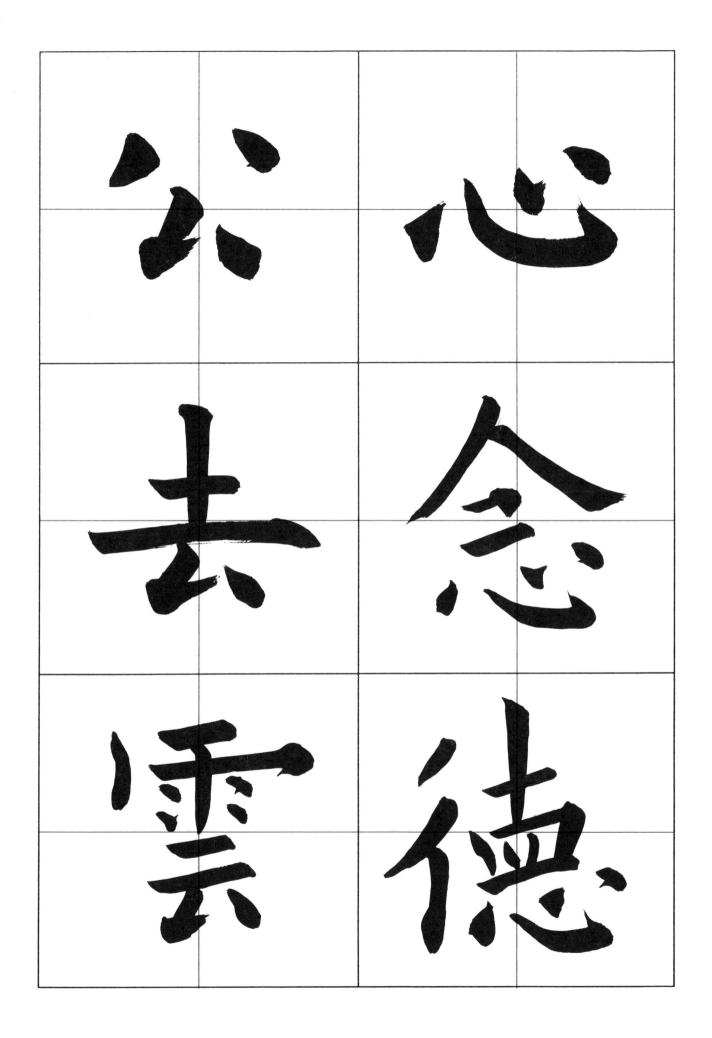

心 念 德

公 去 雲

 1 yasui 2 umi 3 setsu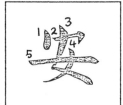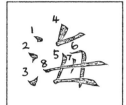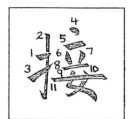

This stroke is very similar to the **hiragana** "ku". The rhythm is basically two beat, pressure at the beginning, none at the corner and pressure again at the end, killing the stroke on the paper. In other words not pulling the brush off the paper. This stroke is the basis of the character for "woman" and can be seen in **yasui** and **setsu**. The combination of this stoke downward left and the horizontal is difficult to balance well. This combination gives the character used for the hiragana "me" (see the hiragana, katakana and hentaigana section).

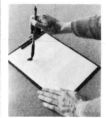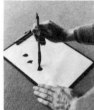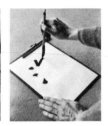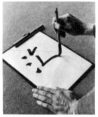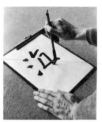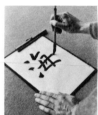

 1 tani 2 izumi 3 tai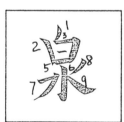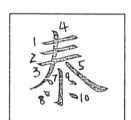

This stroke is called **taku** (cf. Eiji Happō) and is constantly being used. It is also one of those strokes that is difficult to achieve well, but once mastered can be used very successfully in other scripts as well for example **reisho**. The trick is to change directions subtly where the stroke is thickest, but leaving the tip of the brush following the top edge. This is harder to do when the stroke is short as in **izumi**.

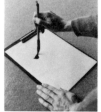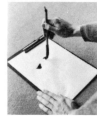

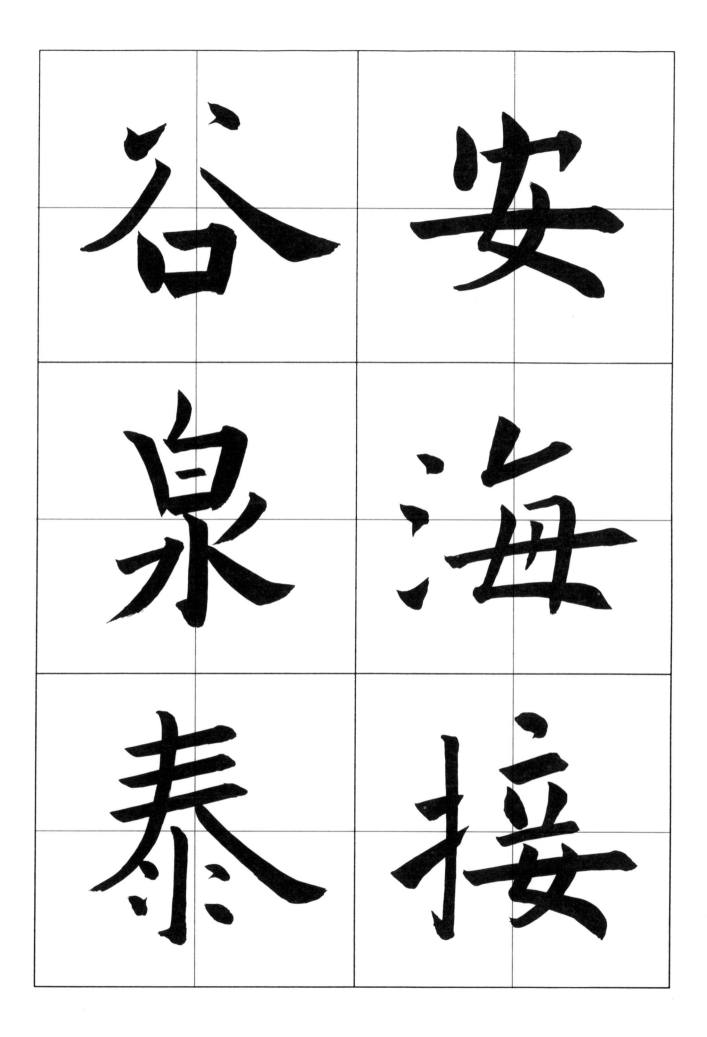

谷　安

泉　海

泰　接

 1 hikari 2 iro 3 miru

 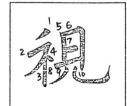

This stroke is fundamentally different from the stroke studied previously in **kokoro**, for two reasons: firstly the stroke has a definite corner to the left and secondly the stroke is horizontal for the most part whereas the **kokoro** stroke was diagonal, but they are similar in the respect that the brush leaves the paper in the same manner. The **kokoro** stroke left towards the top left corner, this one straight for the top.

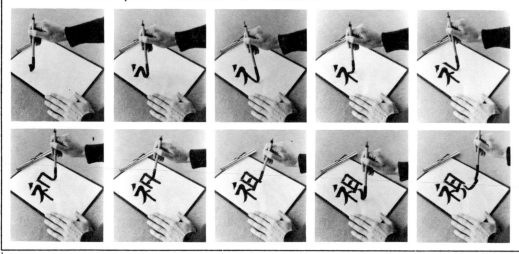

 1 shin 2 sei 3 tei

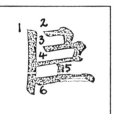

This vertical stroke is different again from the two practised previously. The first hooked to the left, the second left the paper with a curling wrist movement, this stroke however is killed on the paper. It is rather like a vertical bamboo stroke, pressure is applied at the top released slightly and then reapplied at the bottom, but this time the wrist is brought down with the brush rather than the curling wrist drawing the brush through the stroke. The third stroke of **sei** is difficult because of the thinness: one is less likely to tremble if it is written quickly.

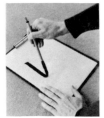 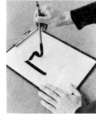 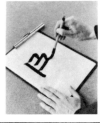 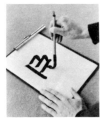 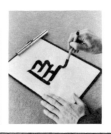

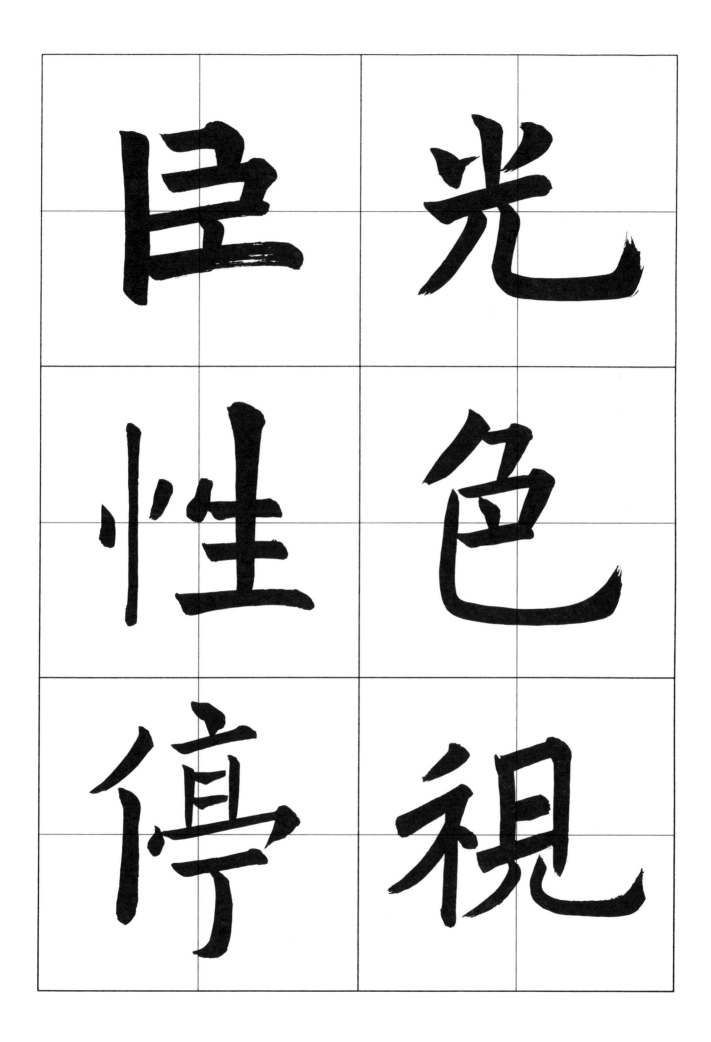

臣　光

性　色

傅　視

 1 gen 2 nagai
 3 tanoshii

The stroke practised in **kumo** looks similar to this one, but it is more than the angle that makes them different. The end of the stroke joins another at nearly right angles, whereas the previous stroke was counter-balanced by a "dot." So the sixth stroke of **nagai** might look more of a **kumo**-type stroke but, for the above reason, it is not. When characters involve many strokes in one part (say the **tsukuri**) and few in another (say the **hen**) make the strokes in the **tsukuri** thin and light to balance the few heavy ones in the **hen**, as in this example of **tanoshii**.

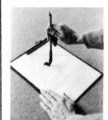 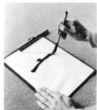 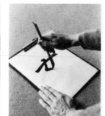 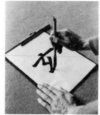 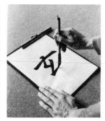 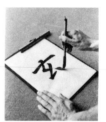

 1 u 2 miya 3 kasumi

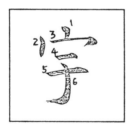 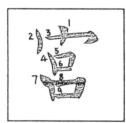

Many **kanmuri** use this stroke. Even though it is horizontal it is not a bamboo stroke, no pressure is applied at the beginning and the minimum at the end. In the character **katai** a similar brush movement was practised; at the end of the horizontal stroke the brush should be repositioned and then brought off to the left sharply. Notice the extra width of the stroke in **kasumi** helps balance the long **taku**, anything shorter and the character would have "tilted" to the left.

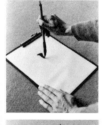

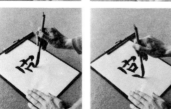

宇　玄

宮　長

霞　樂

 1 na 2 kō 3 han

In many respects this stroke is similar to that used in **tsuki**, but shorter, the angle is also broader. **Kō** is a challenge as it contains seven different strokes, but at this stage the brush should be moving automatically and there should be no need to think where pressure is applied. The challenge should be the **kanga** and **kūkan**.

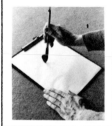 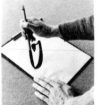 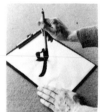 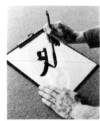 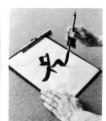 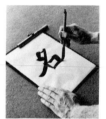

 1 kore 2 tateru 3 koeru

If the principle given for **tani** and **izumi** has been mastered then this stroke will not prove a problem. The two main features of the stroke are its "drooping" shihitsu and the wide tail and slight change of direction. Its main use is as part of a **niyō** as given here. It is important that the vertical stoke of **tateru** sits in the middle of this stroke. The heavy tail well balances the strokes of the **inniyō**.

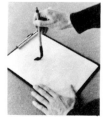 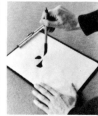 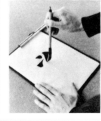 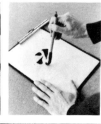 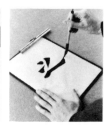

67

之　名
建　敫
越　般

 1 ki 2 kaze 3 hō

 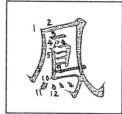

This is another dramatic stoke like that in **naru**, however this stroke starts by descending verically and then arching to the right before the brush flies off to the top of the page. The tail tends to be the centre of attention and can use as much as a third of the space allotted the whole character; so when writing vertically it should be remembered that the **chūshin** will fall over to the right as in **kaze**.

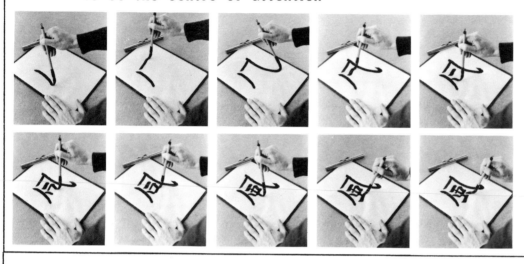

 1 nobu 2 fu 3 kabe

The trick of getting a good dot is first in appreciating how the shape was formed. The brush is placed on the paper horizontally so that the tip is facing the top left corner, and then brought off so that the tip goes either toward the next stroke or the bottom left corner. It will look unnnatural if the tail from the dot is facing some other direction. Notice the weight of the dot is heavier in **nobu** than in **kabe**. In **nobu** the brush was brought off while applying pressure.

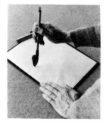 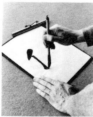 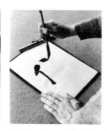

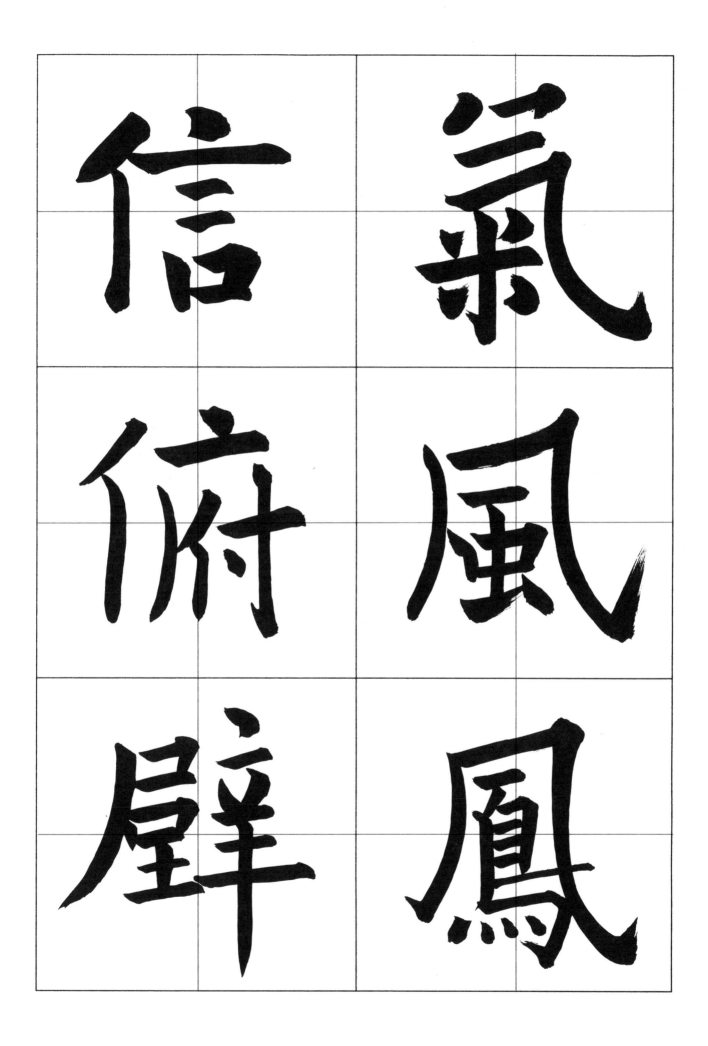

信 氣
俯 風
壁 鳳

 1 nashi 2 tame 3 shika

These four dots come in several combinations: in a line as in **nashi** or ascending as in **tame.** When they are in a line the outer dots can face inwards, as in nashi, or the same direction as in **shika.** Often the two outer dots are made heavier to enclose the middle pair. For ascending dots it is common practice to make them gradually smaller with the first one the heaviest. To make the dot face the right bring the brush in from the left as usual, but lightly and leave to the right with more pressure. If the brush does not come in from the left the bottom of the dot will not be rounded off.

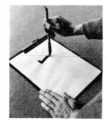 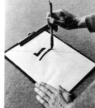 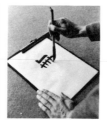 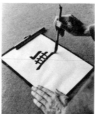 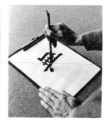 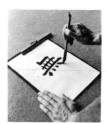

 1 yama 2 hi 3 nomi

This last stroke can be written with or witout pressure. With pressure as in **yama,** the horizontal resembles a bamboo stoke, without, a simple line. When, as in the case of **hi,** the stroke ends in the air, it should be stopped by using a little pressure at the end, but not as much as one would use in a bamboo stroke. **Nomi** is the most complicated character in **Kyūseikyū** and probably incorporates fifteen of the twenty-four strokes in this text. The character is in three main sections top left, top right and the bottom (**kane**) when writing the top two leave a little gap for the top of **kane** to fit in then it will all fall into place.

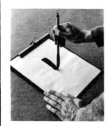 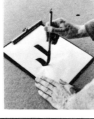 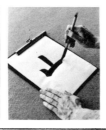 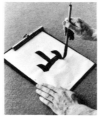

71

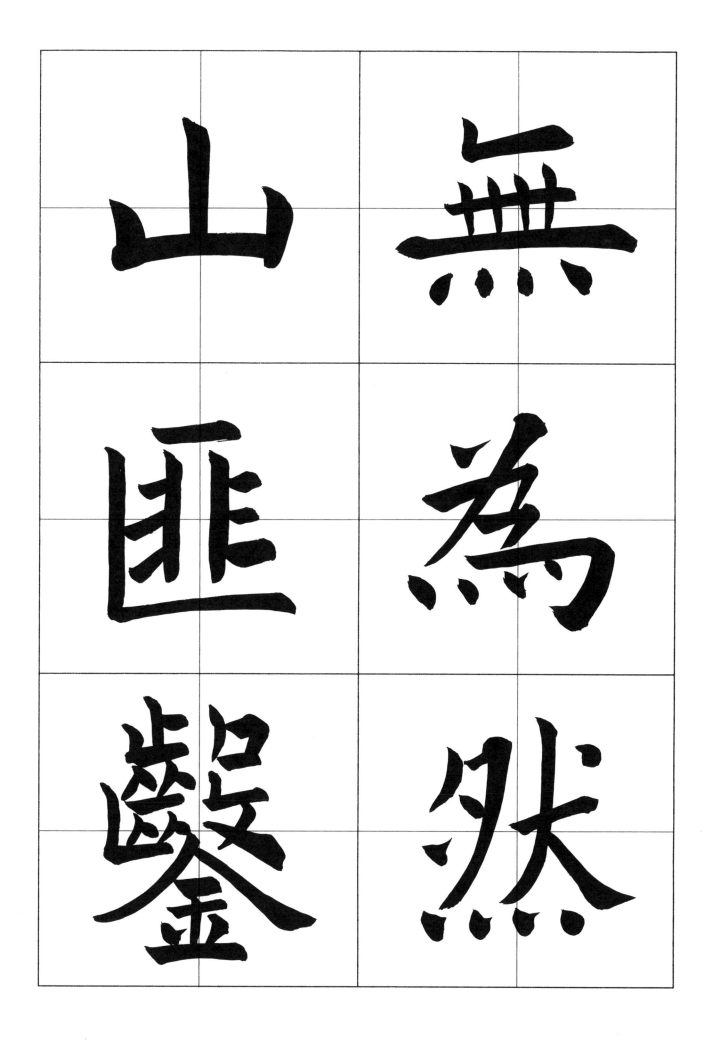

藏　大

聖　唐

教　三

序文

太宗

皇帝

文

寺 製

沙 和

門 福

霅懷

右仁

將集

筆
之
書
王
羲

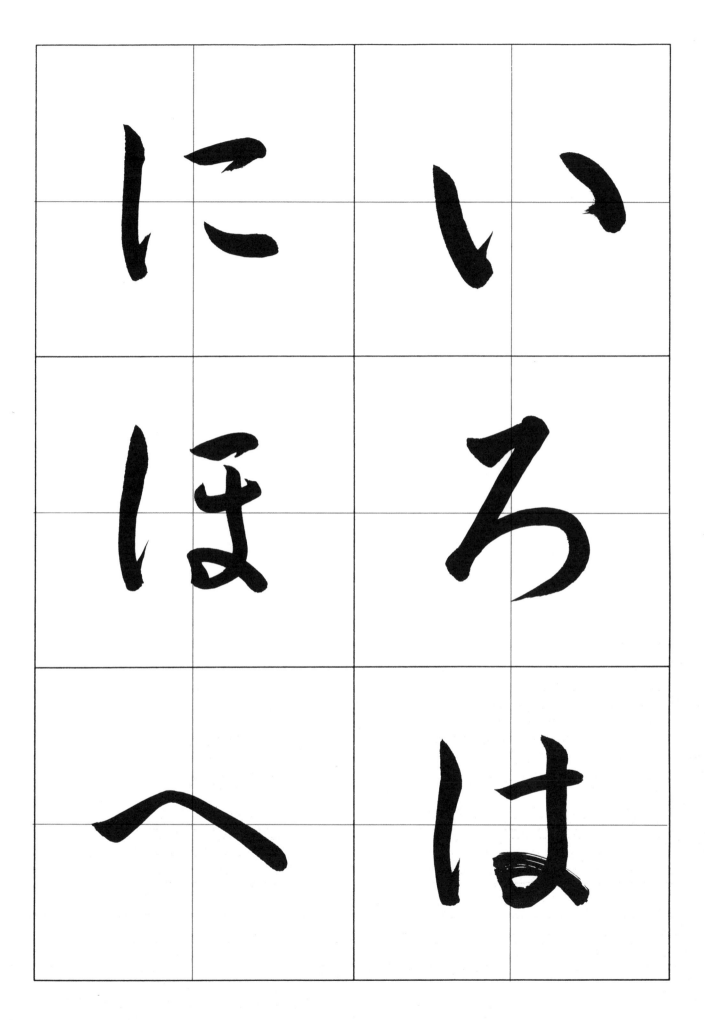

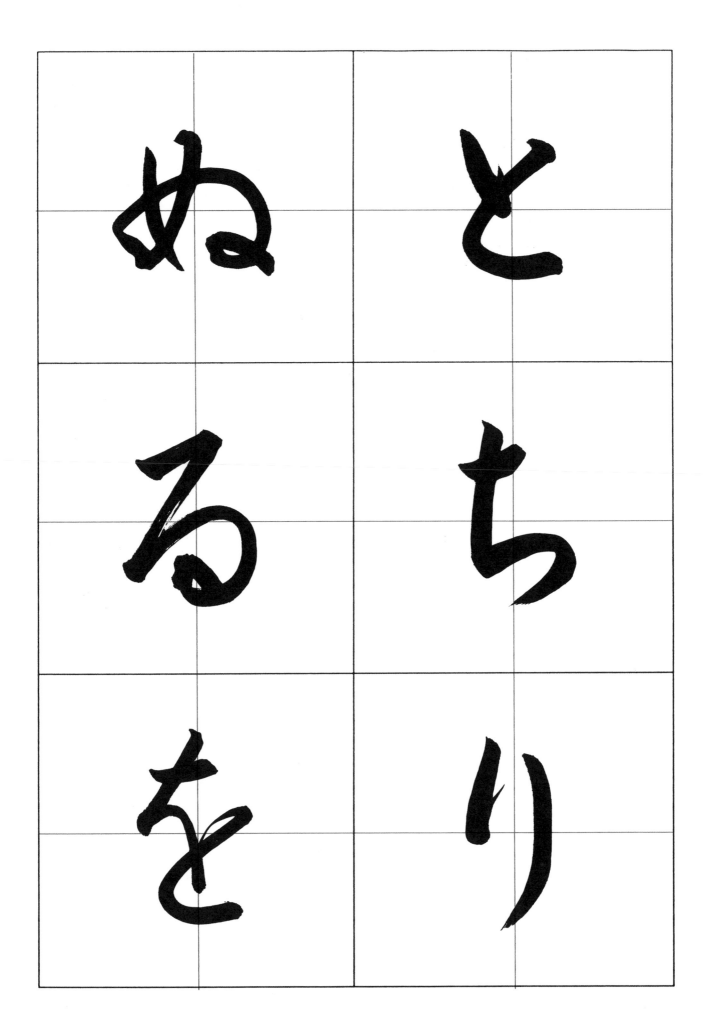

ぬ る を と ち り

た　わ

れ　か

そ　よ

つ ら

ね む

な う

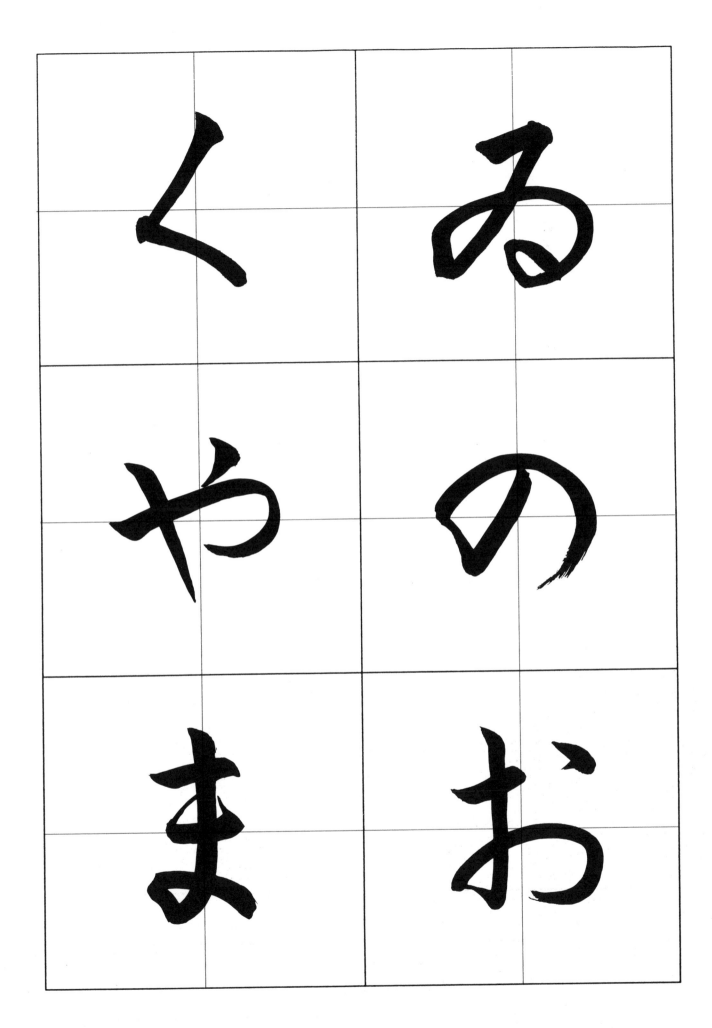

け え

ふ て

こ あ

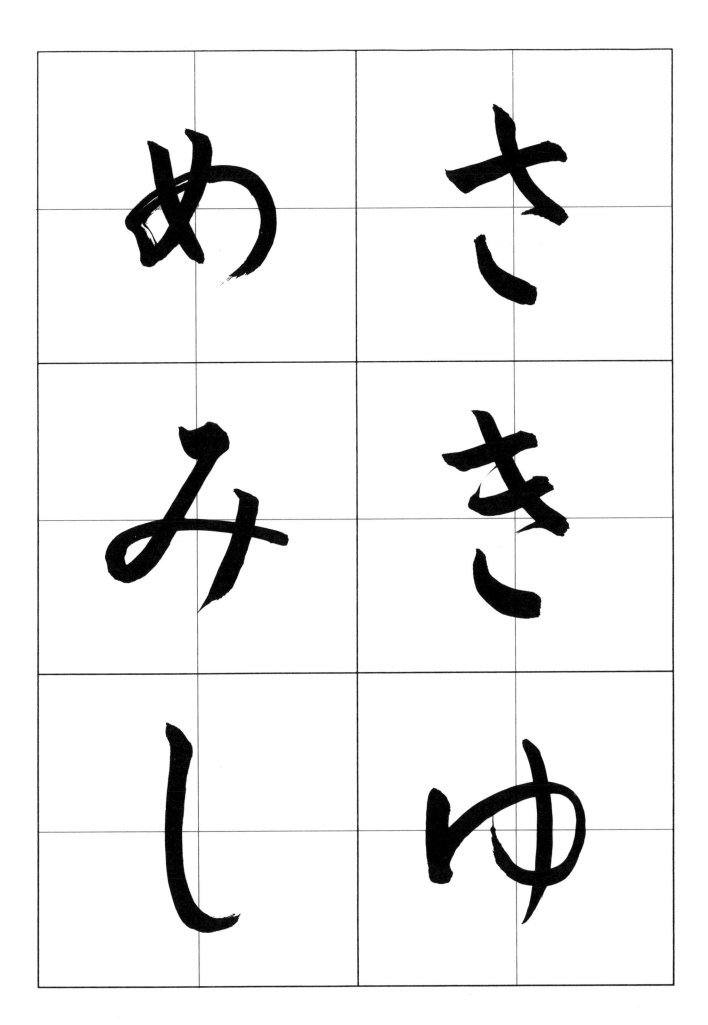

さ　き　ゆ
め　み　し

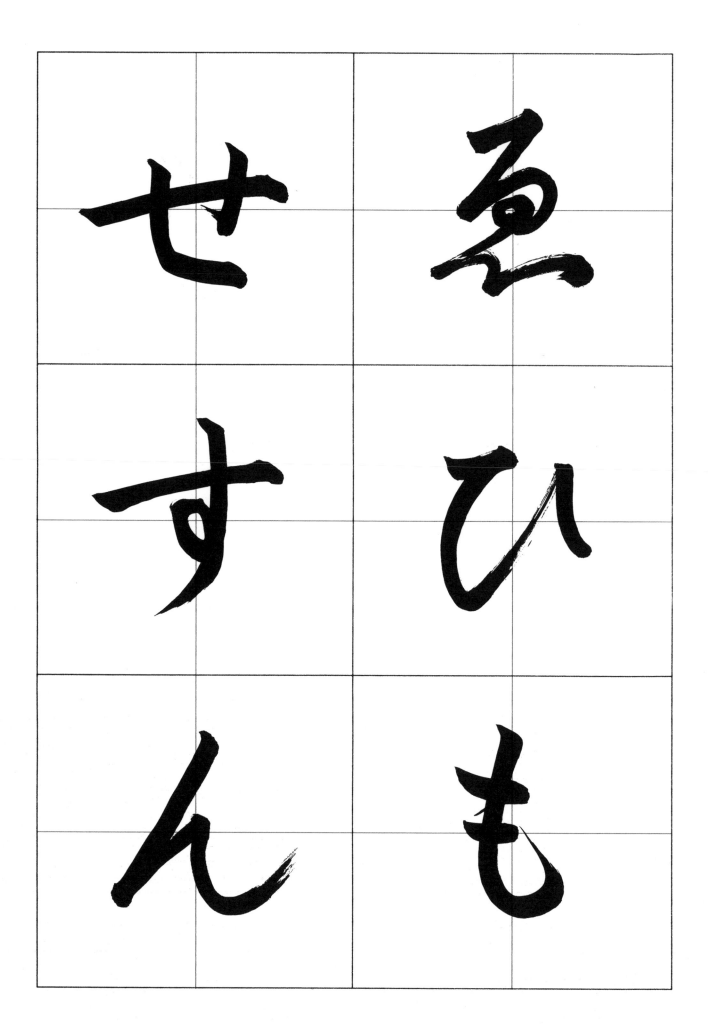

ゑ

せ

ひ

す

も

ん

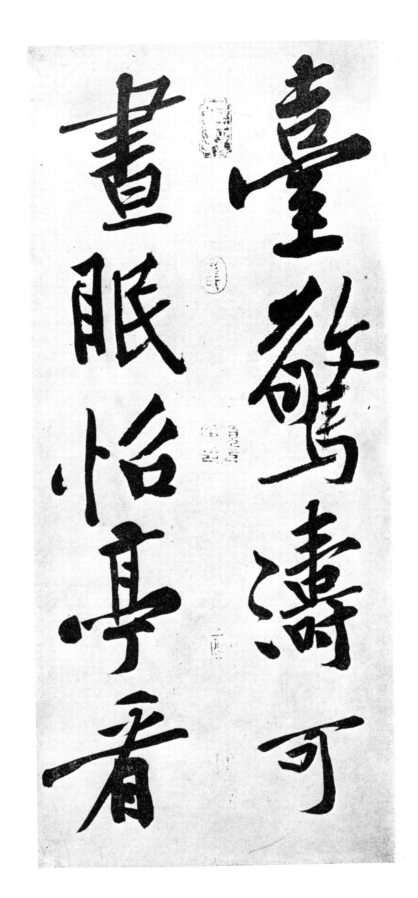

Kō Sankoku's gyōsho

86

BC	CHINA		HISTORICAL EVENTS		JAPAN	KOREA	THE WEST
1500	IN		kōkotsumoji		JŌMON		
1000	SHŪ		daiten on bronze implements	jade seals			
500							
	SHIN						parchment starts to be used
0	ZEN-KAN		shōten	Moten and the first brushes			
	SHIN		reisho				
100	GO-KAN			Tsai Lun 'invented' paper			
200			kaisho gyōsho sōsho			THREE KINGDOMS	
	SANGOKU						
300	SEISHIN		Ōgishi 306?-364?		YAYOI		
		TŌSHIN	Ōkenshi 344-388				
400	H O K U G I	SŌ					
		SEI					
500		RYŌ					
		CHIN		introduction of Chinese culture to Japan	ASUKA		
600	ZUI		woodblock printing in China			SILLA	
700	TŌ				NARA		

AD	CHINA	HISTORICAL EVENTS	JAPAN	KOREA	THE WEST
		Kukai 774-835	NARA		793
800	TŌ	Tachibana Saga Tennō			paper
		No Hayanori 786-842			brought
		?-842		SILLA	to
900		Ono no tōfū	HEIAN		Bagdhad
	GODAI	896-966			
		Fujiwara Fujiwara			
1000		Yukinari Sukemasa moveable			
	HOKUSŌ	972-1016 944-998 type			
		printing			
1100		Fujiwara -China		KORYO	
		Sadazane			
	NANSŌ	1063-1131			
1200			KAMAKURA		
1300	GEN				
			NANBOKUCHŌ		paper now in
1400		Ikkyū		Korean	common use
		1394-1481		syllabary	in Europe-
				1447	Caxton's
1500	MING		MUROMACHI		printing
			AZUCHI-		press 1450
1600			MOMOYAMA	YI	
1700			EDO		
1800	SHIN		(TOKUGAWA)		
	(SHINCHŌ)	Nishikawa Kusakabe			
1900		Shundō Meikaku	MEIJI		
		1847-1915 1838-1922			

The History of Calligraphy

CHINA

The history of China is long, replete with numerous dynasties and in places very confusing for the simple reason that it is a vast country and at any junction in its history there may have been a dozen different kingdoms in existence at the same time.

I have tried to simplify China and Japan's history by means of a chart and show the bearing that certain events have had on calligraphy. Many of the earliest dates for the dynasties are only approximations as no accurate records were maintained then. There was the fact also that as China was so large, it may have taken years to subdue all the peoples of the whole country and establish any particular dynasty. The same might be said of the history of calligraphy - changes and innovations never came about abruptly.

About the twenty-eighth century BC, the Chinese are believed to have used knotted strings to remind them of important matters, the larger the knot the more meaningful the matter. In succeeding centuries, notched sticks supplanted knots and then the notches evolved gradually into stipulated, if primitive symbols for the sun, trees, animals and the like. In the case of a business transaction or legal contract of some

Mokkan

89

sort, sticks were divided and the parties involved retained possession of their particular portion.

The next items of any important historical substance concerning calligraphy were to be found in the **kōkotsu moji** turtle shell characters that Kings of the Shang Dynasty used between 1400 and 200 BC when consulting their ancestors or various gods about military matters. The large, soft shell of a freshly killed turtle was inscribed at the inner surface with appropriate characters and then heated over a fire until it cracked. Soothsayers interpreted answers by reading the pattern of cracks created among the previously incised characters. These first interesting marks are actually the prototype of characters and they may also be seen on the remains of animal bones which were once used in the science of scapulamancy.

By the twelfth century BC characters were being scratched on the surfaces of bronze vessels or printed in reverse on the moulds used to turn them out. These inscribed vessels were primarily for ceremonial use. Script at this point began to take on a decorative appearance roughly equivalent to its meaning and often constituted the most conspicuous design on any given utensil. These characters are spoken of today as **daiten**, greater seal script. However attractive they may have been, they were still difficult to reproduce accurately because of their complex compositions. The same character was often assigned varying meanings, but this is not surprising in such

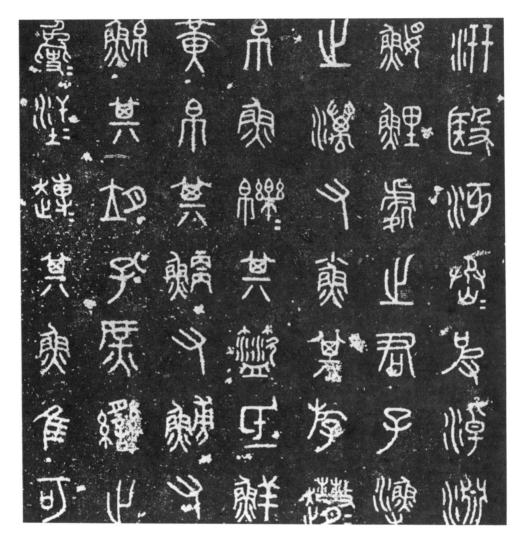

an immense country of different peoples, cultures and languages.

In the Ch'in Dynasty (403 - 221 BC) a strong, ruthless leader emerged who managed to unify the country. His name was Ch'in Shih Huang Ti. He strove to create a strong state with a central administration based on theories of Legalism. One of the most important of his enactments was an instruction to his prime minister, Li Ssu, to reform and simplify the script so that in its standardized form it could perform in an empire of many tongues; all would be able to understand the written symbols even if they spoke mutually unintelligible languages. He even saw to the drawing up of standard primary school textbooks. Until this time characters had been written on **mokkan** strips of wood or bamboo with primitive brushes, but with the introduction of silk as a standard writing material, the ink stick and brush as we now know them developed.

The script Li Ssu developed came to be called **shōten** lesser seal script. The characters were written within the confines of an imaginary square and since its lines were uniform and well balanced, the job of the official scribes was rendered

much easier. Originally three thousand were conceived, but by 200 AD this number had increased to more than ten thousand and was eventually to rise to more than ten times that sum. **Daiten** and **shōten**, together were called **tensho** "seal" scripts because they were used for the carving of official seals even if that was not their original purpose.

Because small seal script took considerable time to write, another script called **reisho** scribe's script evolved. The story of its development is interesting and was in the end fortunate for a certain Ch'eng Miao. It seems this man had offended Shih Huang Ti, a proud man who had dubbed himself the emperor, and was languishing in prison. To pass the time he thought of a way of making **shōten** script easier to write. He made the curved lines straight and the squares circular with the

result that all the lines were shortened and a scribe could then move his brush faster through the prescribed stroke order. These innovations then enabled artists and writers to concentrate on the aesthetic points of shape and balance. The emperor was so pleased he rewarded this man by releasing him. A great deal is known about **reisho** and **tensho** scripts because during the Ch'in Dynasty they were often carved directly on the face of stone monuments and those monuments are still standing in various places in China.

The reign of the tyrannical emperor lasted a mere fifteen years until his overthrow by the founders of the Han Dynasty. The country then reverted to Confucianism from Legalism and Confucius' Classics established as the basis of social education. Standards of the written language were also stimulated by the fact that hidden copies

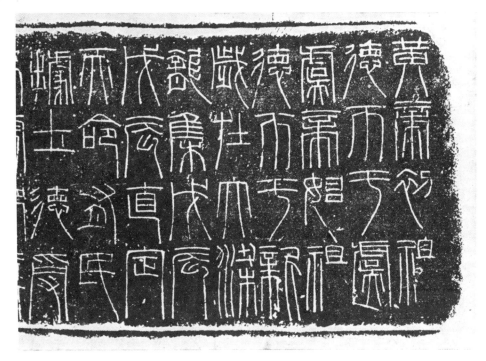

Tensho

of Confucius' earlier banned publications were now brought out and copied for a seemingly insatiable market. Printing had not yet been invented so everything was done by hand. The invention of paper went far toward improving the distribution of books and easier access thereby encouraged study. Writing implements also improved a great deal, but calligraphers began to feel that the strict conventions of **reisho** cramped them too much so they proceeded to evolve a new script which they called **kaisho** standard script.

The complete development of **kaisho** took hundreds of years and it was a very long time before it completely superceded **tensho**. Two other script styles followed soon after-**gyōsho** semi-cursive, comparable to our joined up handwriting, and **sōsho**, actually meaning rough copy, but more often called "grass" writing nowadays, comparable to western shorthand and just as difficult to read. The evolution of these scripts did not take place as one might imagine; **kaisho** and **gyōsho** were in fact formed simultaneously, but in different places and **sōsho** was around before either of them but advanced greatly with the development of **gyōsho**. There three styles were more rational, quicker and easier to write than either **tensho** or **reisho** which in time only calligraphers continued to practise. **Sōsho** on its part quite difficult to read was in essence only within the domain of the experienced calligrapher. Its abstract qualities continue to make it so.

Sōsho requires more care to write than is imagined because a slight variance can mean another character. Choshi, the Han dynasty calligrapher, was once asked to write a passage in **sōsho** but he refused. He quickly explained that he had no time to write it in **sōsho** and asked if another script might do.

The stories that have been handed down about famous Chinese calligraphers are legion. Chokyoku of the T'ang Dynasty is said to have been partial to strong drink and when in his cups would write a beautiful **sōsho** on anything within reach. The trouble was he could not when sober often read what he had dashed off earlier. When very drunk he was known to soak his hair in ink and write with that.

The Chinese have always regarded the ability to write well highly. The famous district, provincial and palace civil service examinations held from the beginning of the T'ang Dynasty to the end of the modern Ch'ing Dynasty depended for the most part upon one's calligraphic skill. To be judged wanting in handwriting meant the loss of a chance at a government appointment.

Calligraphy occupies a prominent place in China's long history and its devotees can quote the names of its most famous practitioners quite easily. Ōgishi, Gan Shin Kei, and Bei Futsu are but a few. These men were legends in there own day; as respected as a maestro of the musical world in the West might be today. Ōgishi of the Ch'in Dynasty, for instance,

was also prolific. His seventh son, Ōkenshi, also became a great calligrapher and together they came to be known as the two kings of calligraphy the two Wangs. It is interesting to note their surname means "king." (The Chinese pronunciation of their names are Wang Hsi Chih and Wang Hsien Chih.) As a child Ōgishi once removed a valuable scroll that his father had kept hidden beneath his pillow. When told to give it back as it was a very important document, too important for a child to be looking at, Ōgishi retored that if it were that important there was no time like the present to be studying it. He made remarkable progress from that time on and outstripped calligraphers many years his senior even as a child. His fame is illustrated in the well known story below.

One hot summer day an old lady was attempting to peddle her fans without much success and she came near Ōgishi. He impulsively seized the fans, much to the old woman's dismay, and wrote on all of them telling her to try once more only tell everyone Ōgishi had written on them. Not much mollified the old lady started out and within the space of an hour had sold all of them. Whereupon she hurried back and urged Ōgishi to write another batch. He only laughed at her because she attempted to take advantage of him.

One day Ōgishi visited the house of a pupil and was greeted warmly. While they shared drinks and conversation the pupil mentioned that he had just finished making a table would the master like to see it. The master was so taken with the table that he immediately snatched up a writing brush and dashed off poem after poem all over the top. The delighted pupil vowed he would treasure this table and pass it to his descendants. The two then left the table to dry and moved next door. The pupil's father came into the house and was so shocked to see the table covered in ink that he brought out tools and attempted to shave all the writing off the top. He had not properly estimated the power of Ōgishi's work, however, for work though he might he could not remove the of the letters. This story has since come to be known as **jubokudō**, "the way of the powerful brush," and the moral of the story extends to all methods of calligraphy in general.

This man was fond of practising his large works of calligraphy on whitewashed walls. One day having just finished writing on his walls he went to town on business. While he was away his son Ōkenshi repainted the wall and painted it over with his own calligraphy thinking that he would not let his father outdo him. On his return Ōgishi looked quizzically at the wall and said that he realized he had had a few drinks before he had left, but that surely he had not been that drunk. Years later Ōkenshi, by then an established calligrapher very popular in his own right, was fond of quoting this story as an example of nothing being so bad as conceit.

Once a friend came to the house of these calligraphers hoping to be given some small work or other, but the son being as impulsive as his father chose to write all over the friend's new silk gown. The friend, more than being grateful, was embarrassed about what people might think of him. As soon as he returned to town and people saw him, a crowd formed and began to tear this garment from his back. In an instant he was left lying on the ground with only a sleeve remaining. Thus was Ōkenshi's work valued in his own day. Very few of his original works remain today. One of his principle works was an edition of the **Book of the Yellow Court**, scriptures in seven syllable verse of **Taoism**, the doctrine by Lao Tzu to which Ōgishi subscribed. Fortunately contemporaries made numerous copies of this man's work which may be observed today.

Another offshoot of the development of characters in East Asia took place during the Han and Six Dynasties eras of China. In Kan Su province, characters called **Hsi Hsia** once developed free of outside influences. These characters on examination are obviously too cramped and possessed of far too many strokes to have much aesthetic appeal, but they must be mentioned nevertheless because they are one more form of the art.

JAPAN

Calligraphy began to filter into Japan near the end of the Asuka Period (circa 645 AD). During the seventh century and later, great missions to exchange scholars, monks and statesmen between China and Japan called **Kenzuishi** during the Sui Dynasty and **Kentōshi** during the T'ang Dynasty took place. Buddhism from India had swept across China through Korea and was then on the point of converting Japan. With that movement came characters as Buddhist scriptures were recorded in Chinese writing. The calligraphy was written by priests and it was esthetically very pleasing. Being the creation of devotees of Buddhism it induced considerable "religious awe" in potential converts. Japanese emperors, zealous converts to this new continental faith, encouraged this movement. In time the calligraphy of religious documents was adapted by priests of the Zen persuasion and they added their own inimitable character to the original Chinese works. It is called **bokuseki** and its most famous exponents were Daito, Ryokan and the modern Hisamatsu Shin'ichi, all priests.

Three great Japanese masters of calligraphy called the **sanpitsu**, "Three brushes", emerged during the Nara Period (645 - 794). These men were the Emperor Saga (786 - 842), the priest Kūkai (774 - 834) and the courtier Tachibana no Hayanori (? - 842). Calligraphic works imported from T'ang China influenced these men considerably. Their works

95

were built upon by Ono no Tōfū (896 - 966) who is also known as Ono no Michikaze. This man is credited with the development of a truly Japanese style of calligraphy.

Two other men who with Ono made vital contributions to calligraphy in Japan were Fujiwara Yukinari (972 - 1016) and Fujiwara Sukemasa (944 - 998). They all lived during the Heian Period (972 - 1016) and were known as the **sanseki,** three prints. They were the calligraphers who contributed the most to the development of the Japanese syllabaries. The **Kokin Wakashū,** a collection of Japanese poetry dating from this period attributed to Fujiwara Sadazane (1063 - 1131) is a collection of thirty-one syllable stanzas in kana on decorative paper.

Stories of Japanese calligraphers are not as plentiful as those of their Chinese counterparts, but one is worth retelling if only because every Japanese person knows it. It seems Ono no Tōfū was walking along a river one rainy day when he saw a small tree frog trying to jump up to the leaves of a willow tree bending low near the ground. Try though the frog might he could not succeed in gaining his objective. Just as it appeared he would have to abandon his struggle the frog managed to catch the tip of a leaf in his mouth and crawl up in to the tree. Ono no Tōfū who at the time had become quite dejected about his calligraphy was very much encouraged by this scene and resolved to persevere far more than he ever had with his chosen art. It is well he did because he went on to become

one of the country's most celebrated calligraphers.

Basically two types of calligraphy evolved over the years in Japan, **karayō,** a style rich in techniques and tradition which owes its existence to studies made of Chinese works and **wayō,** a delicate yet simple feminine feeling script which is indigenous to Japan.

The formation of the **kana** syllabary came about as a form of **sōsho** and appeared early on in the middle of the eighth century in the **Man'yōshū,** The Collection of a Myriad of Leaves. This is a collection of 4,500 distinguished poems and was the first and some say the most important contribution to the literature of Japan.

During the Heian Period a sexual differentiation first appeared in calligraphy that in some respects persists even today. Certain forms of **kana, gyōsho** and **kaisho** were principally used by men so were called **otokode,** "masculine hand" and the most generally simplified form of **hiragana** was the preserve of women so it was called **onnade,** "feminine hand". **Sōsho** lying on the boundary between the two as it did was used by both genders. It was so closely akin to **kana** that it was often freely mixed with characters and linked into long chains of twenty or more characters. This conjoining of Chinese characters and the syllabary is known **chōwatai** a harmony of types and the joining of characters into long chains **renmentai.**

Perhaps the best known Japanese calligrapher was the Buddhist monk Kukai. Born into an obscure family of Shikoku, one of Japan's main islands, he followed his uncle's example and went to university. At twenty, however, he gave up this endeavor to opt for the priesthood of **Tōdaiji** then the most prominent temple in the capital of Nara. There he received the name that would follow him for the rest of his life, Kūkai. He became dissatisfied with the examples set by other monks at that temple though and set off on his own for the mountains deep in the interior of Shikoku. After sojourning there for several years he learned that the famous priest Saicho intended to visit the capital of T'ang China and Kūkai resolved to accompany him. He obtained an appointment as a delegate in that particular **Kentōshi** mission of four ships and departed for the continent. The China Sea can be a treacherous body of water to traverse depending upon the time of year and this voyage was no exception. A dangerous storm blew up and Saicho was lost overboard. Kūkai's boat was fortunate enough to be washed ashore in China, but without the proper papers, the Chinese were unwilling to allow Kūkai to proceed inland. Kūkai then sat down and wrote a letter of explanation to the nearest official who on seeing the masterful handwriting and elegant prose immediately assumed that the author must have been an ambassador of considerable standing and welcomed him with all due ceremony. In total it took them six months to make the journey to the capital and he was to reside there for three years. His reputation as a calligrapher preceded him, however, and one day Emperor Tokusokutei summoned him and asked him to rewrite a section of a badly damaged five panelled screen that had been written four centuries before by Ōgishi. Once he surveyed the problem he is said to have picked up a brush in each hand, gripped one between the toes of each foot, clamped another in his jaw, and immediately written five columns of verse simultaneously. For that he earned himself a place in Chinese legend and was given the nickname **gohitsusho**, the five brush priest.

Another story, taller by far, but equally as famous concerns a plaque in the Kongōjo Temple. Kūkai was asked to make a composition which would be displayed overhead all the worshippers. As it happened the river which ran before Kūkai's home was in flood which prevented his receiving the wooden plaque in question from the temple authorities. The temple delegation therefore was directed to hold the plaque in such a way that it faced Kūkai and the priest dipped his brush in some ink at his side before flicking the ink across the width of the stream to have it land as perfectly formed characters on the plaque at the other bank.

More believable is the tale of the time he was commissioned to write a plaque for the temple of Ōtenmon. As the plaque was raised to the lintel of the gate he noticed that a crucial dot was missing from one of his characters so he tossed his brush laden with

ink up in the air and it landed just on the appropriate spot! No wonder this man was regarded as a Buddhist saint. When he passed on he was given a name to take to heaven in accord with Buddhist tradition and that name was **Kōbō Daishi**, the same man referred to in the earlier discussion on brushes.

After those days other famous names in the world of calligraphy have come and gone, but a few remain in the conscience of the nation and ought to be noted. There was another priest known as Ikkyu (1394 - 1481), more recently Kusakabe Meikaku (1838 - 1922), an example of whose work is shown earlier in the book and Nishikawa Shundo (1847 - 1915), father of a now prominent calligrapher.

Zen and Calligraphy

Writing done by priests is called **bokuseki** and differs from work done by professional calligraphers in that it is more a manifestation of a religious enlightenment. It is a form of "religious art" that more often that not ignores classical standards and criteria.

Works done by Chinese priests in the late twelfth century was very highly regarded in Japan and indeed influenced many people there. The result was many late thirteenth and fourteenth century Japanese priests also produced such works as a means of expressing their own religious experiences. The art of

famous Zen monks such as Shuho Myōchō (Daitō Kokushi), Ikkyū Sōjun, Musō Soseki, Ryōkan and more recently Hisamatsu Shinichi who is best known for his **chōwatai** were displayed in temples and the **kozashiki** four and a half mat rooms associated with the ceremony tea. Indeed Sen no Rikkyu, founder of the ceremony tea, considered **bokuseki** rather than conventional forms of calligraphy as being elementary to the ceremony. He said it introduced a correct atmosphere into the tea room and placed the tea master and his guests in the proper frame of mind to partake of the ceremony.

Priests were calligraphic amateurs who possessed disciplined souls, but uninhibited brushes. They cared little for the finesse of calligraphy and often wrote in jet black ink and made no attempts at creating contrasts through the quality of their ink.

Themes of Zen works need not be associated with Buddhist teachings. Two themes that are nevertheless common to this kind of painting are **enso** zen circles and the **koan** the zen conundrum. The circles are drawn beside a poem or a phrase to indicate a feeling of satisfaction, perfection or completion. The circle normally begins at the bottom of its circumference and turns clockwise. This is opposed to circles of the west which will start at the top and proceed in a counter-clockwise direction. They can be tight circles or large thick ones. Some have ends that barely touch and others ends which

overlap. All are in accord with the feeling the artist hopes to convey.

The second common theme, the **koan** is a catechismal question used in zen meditation. For example **mu** means nothingness, but it will not be used in that sense. Even the casual onlooker must have some experience, however slight, to really grasp the heart of the words **monku no kokoro**. The work of the Zen artists often fascinates people because it speaks to their souls even if it is not particularly skilful.

Through strict training and long practice Zen monks can achieve enlightenment and the ability to express their spiritual feelings. This is not to say, however, that the work of all priests manages to capture the spirit of **bokuseki**. In fact many secular calligraphers can write equally emotive works even if they do remain bound by the importance of form. Zen artists strive to portray the significance of the object of thought by simplicity. I am convinced that in calligraphy as in Zen meditation, concentration is the key. A writer of the Sung Dynasty summed it up in two words when he aptly called calligraphy **Hsin yin**, "prints of the soul."

KOREA

The Korean peninsula has forever been either in or out of the hands of the Japanese and Chinese and the ebb and flow of those two cultures have left an indelible mark on the history of that land. Although a Korean syllabary was devised as early as 1447, Chinese remained the language of officials until the mid-eighteenth century and even now occupies as much as ten per cent of the script.

In the Three Kingdom Period of Korean history, 57 BC to 668 AD, there is evidence that stone monuments such as those of China were produced. The T'ang culture of China had considerable influence on the Korean Kingdom of Silla (668 - 935) and no doubt was instrumental in the development of the most memorable calligraphers of this age, Kim Saing and Choi Ch'i won. This period of history was followed by the Kōryo Dynasty (918 - 1392) and the Yi Dynasty (1392 - 1910) during which time the calligraphy of Han Ho and Yi Kwangsa became famous. In the nineteenth century Korea once more forged strong relations with China and the Ching Dynasty. It was in these years that a form of **kaisho** called **Ch'usa** evolved. It did not seem to have much staying power, however, because once Japanese suzerainty was established in Korea, Japanese forms overshadowed it. The policy of Korean governments since the 1960's has been to purge Chinese characters from the language and encourage the birth of a Korean style of calligraphy.

The Four Treasures

Chinese pedants and poets meant by "four treasures" **bunbōshihō**, the four items without which they could not work. Specifically that meant the brush **fude**, inkstick **sumi**, paper **kami** and their inkstone **suzuri**. In ancient times these were referred to as a person's **shosai**, study.

Brush **fude**

In China this instrument is called **pi** and in ancient Japan it was known as the **itsu**. The present Chinese character used to represent the word includes a radical for bamboo over the original. The character depicts a person's hand holding the brush. It is easier to discern in the earliest **shōkeimoji** form of the character. Brushes are said to have been invented sometime about 200 BC by Moten who made the first brushes of deer hair wrapped with sheep's hair. There is a memorial statue to Moten at the Mimeguri Jinja in Tokyo. In the Edo Period a brush was called **kanjō** and the person who made them **kanjōshi** (a famous kanjōshi from the Meiji Era was Takagi Juei). Japanese made brushes are called **wahitsu** and Chinese manufactured brushes **tōhitsu**. Japanese products are often made up of as many as ten different animal hairs mixed together, but the Chinese brush tends to be more pure and will make use of only four of five different types of hair. The most popular material is hair from the breast of the Chinese sheep because it is mostly straight. Mixing hair to make a brush is nothing bad, it is just that every hair has different qualities which controls the degree of versatility.

Hairs on a brush are known as **ke** and the handle **jiku**, but the formal term is **hikkan**. The handle can be made of anything including gold or ivory, but it is more common to use bamboo, wood or plastic. Brushes used in the eighteenth or nineteenth centures were shorter than those in use today. There was a saying that the handle of a brush was only **hitonigiri han** a fist and a half long, but now two fists are more common, except for brushes that are used for kana. Brushes will come in fairly standard dimensions and size is determined by the breadth of the hair where it meets the handle. Their numbers will range from one to ten and mean that the width of the brush begins at about half a centimeter and reaches a maximum size of three centimeters. Larger brushes with as much as eight centimeters in width are available, but they fall outside the scale. A general purpose brush good for either **hanshi** or **jōfuku** would be a medium sized **chūbude**. A Chinese brush would be read in the opposite order with the higher number indicating the smaller brush.

The importance of the scale is to give guidance as to how wide a stroke the brush can write. There is one more consideration to keep in mind, hair length. The length of

the hairs will usually be in proportion to the width, but two types of brush exceptions to this are the very short sparrow's head **jyakutō hitsu** and short blade **tanpo** and the willow leaf brushes **ryūyō hitsu.** The former is rarely ever seen now though in ancient China it was the only brush available. The latter is very common and quite useful. It is long and thin and writes delicate strokes even if the hairs tend to separate easily while writing. Hairs will be one of the following: sheep, racoon, sable, deer, weasel or cat. These creatures grow thicker coats in the winter to fend off the cold so the winter coats are called **fuyuge** and summer **natsuge.** Most animal hair can be rendered into brushes. Ōgishi is reputed to have made a brush of mouse whiskers **shōshuhitsu** for his famous work **Ranteijo.** These brushes are still available nowadays, but prohibitively expensive, because a single mouse has only six whiskers and one brush requires dozens of these hairs. Once it was possible to buy a traveling case for brushes which even had a small container for ink. Its design was the shape of a quiver for arrows, only smaller, hence its name **yatate.**

Every brush will have some mark on it giving a clue as to its softness. If it is a **gōgōhitsu** 剛毫筆 it will be hard and springy because it is made of horse's hair or mouse's whiskers. A **kengōhitsu** 兼毫筆 is hard inside and soft outside. The **jūgōhitsu** 柔毫筆 is very soft.

Brushes are made by the following process: Hair is collected so that the cut ends are all aligned. Hairs are graded for quality and length. Small bundles are made of hairs with the longest hairs and best hairs in the middle of the brush. Then they are tied and glued into the end of the hollow bamboo handle. Lastly the brush is shaped slightly and starched so that all the hairs are together in a single bunch and then the name carved into the side of the handle.

When purchasing a brush four things are to be kept in mind. There are two basic kinds, **katame fude** the still starched brush and **sabaki fude** the brush with loose bristles. The loose one is easier to examine when making your choice. First feel the top of the brush to see that it thins out gradually as the tip is approached. It should not taper too soon. There ought to be a sheen to the tip and the longer these shiny bits are the better. Bring the hairs together to see if they really do form a point. See too if there is one hair a bit longer than the others and perhaps a bit more stout. This is the **inochi ge**, the life bristle, and it is very important in giving a final tail to your stroke. Finally hold the loose brush sideways to determine whether or not the hairs will collapse limply to one side. If they do that is bad. The spring in the hairs may also be determined by tapping the fingernail against the handle and observing how the hairs spring. Most calligraphy shops will have one loose brush for every type of brush they sell. In the end of

course the only true test of a brush is how it writes and the better shops will allow you to test the loose brush on a special piece of paper called a **suihitsuban.** It is somewhat like slate in that it goes black when it comes into contact with water. This is also marvellous incidentally for children to use when they are learning calligraphy. Brushes have always been rather expensive and in old times probably even more than now to have been though of as a "Treasure." In the T'ang Dynasty a monk called Chi Ei treasured his brushes so carefully that by the time he reached old age he had accumulated dozens of baskets of old brushes. He chose an appropriate day and held a memorial service for all of them. People were so interested in obtaining the works of this man that they crowded around the gate of his home in such great numbers that they damaged his gate and walls. He finally had to mend the holes with a great sheet of iron and that earned the nickname of "Old Iron Gate." The ancients took such good care of their things that their traditions have extended to the museums of today.

How to make a brush of your own

Making a brush is quite difficult. If you try to use human hair you soon discover it has no spring even if the uncut hair of babies may sometimes be made into a brush. There is, however, an interesting brush that may be made from a branch of wisteria bush. It cannot be bought in shops. First find a length of living wisteria branch (I suppose some other branches might work just as well) and cut off about thirty centimeters. Then put the end you intend to use for the bristles in boiling water for an hour. After it has softened take it out and tap the end lightly with a hammer. You will see the fibers spread out much like a brush. It will not hold ink well and soon hardens again so that you will have to soften it once more in hot water, but the effects are quite different.

To once more starch a brush after it has been opened, use either a thin solution of **nikawa,** the glue described in the section on **kokuji,** or make a thick solution of starch and stir the brush through it well, reshape it and hang it out to dry. Large brushes are sometimes fashioned by taking several smaller brushes and wrapping them together so that finally only the tips are showing. This sort of a brush will hold ink very well, but its hairs are so short that it is not practically of very much use.

Inkstick **sumi**

Sumi inksticks are hardened rectangles of ink which are to be differentiated from another variety of ink in bottles of which more below. Basically there are four types: plain black, black with gold leaf or some other substance in it, grey ink known as **shōenboku,** deceptive

because no matter how hard the black stick is rubbed it only yields grey coloured ink, and dark grey ink that contains oil **yuseiboku** so that when writing a character it is always outlined in a spreading pool of oil when finished. The third and fourth types of ink are particularly popular among artists practising **shōsuji**, limited number of words and **kindai shibun** modern poetry expressed in modern language forms. **Sumi** has its name written on the outside of its container and this will give some indication as to its make up. If you are not sure, however, ask a shop assistant to see the "colour card" as most reputable establishments will have information on the inksticks they sell.

Chinese inksticks are referred to as **tōboku** and Japanese **waboku.** All **tōboku** are black and often have circles at the top describing the blackness of the ink. Five circles would indicate the blackest shade.

Sumi is made of soot and glue. The soot is collected from an inverted dish which covers a lower dish filled with burning oil. The three most common oils used are rapeseed, paulownia and sesame seed. The glue that is used is a natural substance made from the hides and bones of animals, either cows and horses in Japan or whales in China. It is called **nikawa**, or **funori** if it is made of vegetable substances. The two are mixed together to obtain a thick consistency and then left to dry. The best varieties have had this done several times over so that it has been built up in layers.

After the last kneading it is placed into moulds and dried. The proportion of glue to soot is also important, the more glue the thicker the substance at the end. This ink is known as **nōboku,** thick ink. **Tanboku** is the term for thin ink. **Shōenboku** the grey coloured **sumi** was made from the soot of pine needles until the Edo Period and that accounts for its popular name, "pine smoke ink." Since then though it is almost exclusively made of oil, the real thing being now quite rare and costly.

The older the **sumi** is the better, as it matures nicely with age. The old sticks are referred to as **koboku,** old ink. Especially famous among those varieties are the sticks manufactured during the Ming Dynasty by Teikunbo and Horo. They cost the equivalent of several thousand dollars apiece. As with many things these days, however, there are imitations of even these precious things. Impressions are made of the real things and then moulds formed to turn out inferior forgeries **hokoboku.**

Sizes of **sumi** are determined by their weights. Chinese sticks begin with one **chō** and progress downwards to sixty-four **chō.** Japanese products begin with one and work their way upwards to sixty-four. Sizes double with each step however and are to be reckoned one, two, four, eight, sixteen, thirty-two and sixty-four. Their weights are approximately as follows:

	Chinese	Japanese
1 **chō**	600 gr.	15 gr.
2 **chō**	300 gr.	30 gr.
4 **chō**	150 gr.	60 gr.
8 **chō**	75 gr.	120 gr.
16 **chō**	32 gr.	240 gr.
32 **chō**	16 gr.	480 gr.
64 **chō**	8 gr.	960 gr.

Sumi also comes in varied shapes. The four principal divisions are : rectangular **tei** (most common), circular **ki** (perhaps fashioned with a handle to make it resemble the lid for a tea pot), square **u**, or other shapes **zappai** like butterflies, tortoises and the shapes of the gods **ningyōboku**. Such sticks as **zappai** are basically for collectors and will hardly ever actually be used.

As I mentioned at the outset there are two forms of **sumi**, the hard forms **kokeiboku** and liquid inks called **ekitaiboku**. The latter are generally called **bokujū** or **bokueki**. Most people think that the liquid varities are a new innovation, but in fact there was a form of liquid ink in the Meiji Period, late nineteenth to early twentieth centuries made of carbon black and **funori** which were combined with a scent **kōryō** as the ink often turned sour. Later antiseptic **bōfuzai** was used to prevent the ink from going bad. Modern **bokujū** has improved very greatly and can now even be purchased in a ready to use form or a concentrate called **neriboku** which will be watered down by as much as ten to one ratios.

The more water that is added, however, the paler and thinner the ink becomes. When it comes to the production of a serious work, **sōsaku** there is a good chance the prepared inks will run so it is preferable to do the real thing with stick ink.

Paper **kami**

The invention of paper is attributed to T'sai Lun about 105 AD, but rather than give full credit to him I think paper was more likely the culmination of the work of many. It was introduced to Bagdad by means of the Silk Road in 793 AD and was used commonly in Europe by the fourteenth century. Paper used in China was made of the bark of mulberry bushes and that plant did not thrive in a European climate so papers made of linen and cotton was developed. The word "paper" derives from the name of an Egyptian reed, papyrus. Before paper the Europeans used parchment, an animal hide. It could be scraped, washed and reused. Parchment became widespread about 300 BC and before that clay or wooden tablets were the only available writing material. As was explained in the section on calligraphy, the Chinese moved from writing on slips of woods and bamboo on to pieces of silk and lastly paper.

Paper made its way to Japan via Korea about 600 AD. Mulberry abounded in Japan and during the T'ang Dynasty much beautiful paper was also imported to be developed by Japanese into a fine art which

would see floral patterns, bird motifs, sprinkling of gold leaf and the introduction of bright patterns on to papers known variously as **koyagami** or **hanryū**. Sometimes paper was torn apart and many attractice segments of different papers combined to form a collage, for example **Iseyama gire.**

Paper has become reasonable in price and therefore available to everyone only in the last couple of hundred years. In old times it was a luxury and stories of calligraphers such as Teiken who wrote on persimmon leaves are understandable. He normally wrote on paper only after he felt totally competent with the forms he had been practising. Oyoshu practised by tracing his forms in the dust of the road. Shoyo wore holes in his bedding as he traced characters over and over again on the cover with his finger. Even as late as the 1950's good quality **hanshi** was dear and people customarily practised on a wad of very cheap paper, often newsprint folded into a book called **sōshi.**

Japanese paper is called **washi** and Chinese **tōshi** or perhaps **karagami**. Western paper is known as **seiyōshi.** Types of paper are endless and without looking at and feeling them any attempt at explanations is fruitless. Let me say only that Ramonsen is a good Chinese paper when wet and ideal for making rubbings. Thicker papers are called **atsugami.**

Paper sizes are in large part predetermined. In the shops it will be sold **hanshi** size (24 cm x 33 cm) for practise, **hansetsu** (35 cm x 135 cm) and **zenshi** (70 cm x 135 cm). The largest commercially avilable paper is **zenshi** and it is divided lengthwise into quarter, half and three quarter dimensions. A quarter is called a **ren**, half **hansetsu** and three quarters **ren'ochi.** These long pieces of paper are used primarily for working on **jōfuku** pieces, any long work written vertically. In the old days this meant all the works were to be done up as scrolls (**kakejiku**) to be hung in the **tokonoma** alcove. Nowadays framed works are more popular than scrolls probably because it is so expensive to back them by **hyōgu.** Sometimes it is possible to run across **mino ban no hanshi** which is similar to **hanshi**, but larger and thicker (28 cm x 40 cm) because it is used for invitations or official forms such as curriculum vitae, but this is rare.

In China New Year greetings are written on a pair of **ren** or even **hansetsu** and mounted as scrolls to be hung at either side of the entrance to one's home as a greeting to guests who may call. They are called **sui ren** or **tui ren** in Chinese which means couplet. The example given previously done by Kusakabe Meikaku is an example of such a work.

Two sizes are popular for the **bokuseki** of tea masters and Zen priests, the **kengaku**, often half the length of a **hansetsu** and **ocha gake**, tea ceremony ornament, which is mounted in the tea ceremony room. There are other ready

made sizes including the fan shape. As you may know there are two fans used in Japan, a stiffened roundish one called the **uchiwa** and a folding one called a **sensu**. The piece of paper shaped like the round one is called **benmen** and the one shaped like the folding fan **senmen**. When writing calligraphy on a folding fan, buy white and write **kana** on it otherwise a composition is quite difficult to execute with larger brushes as they go over the ribs.

Lastly there is the ordinary **shikishi** or paper square 24 cm x 27 cm which is used for autographs or just one or two characters. It is already backed with cardboard and has a gold edging. Because they are a standard size it is an easy matter to find a frame for one. Another common dimension for paper to be used with calligraphy is one called the **tansaku**. It is approximately a quarter the area of a **shikishi** and expressly for **kana**. Rather than frames, this size paper is slipped into small holders.

How paper is made

Paper has to be made in the cold season, between November and March, else the glue used in it goes bad in the warmer weather. Paper is made of hemp, mulberry or two other related plants called **ganpi** or **mitsumata**. The last two are native only to Japan so there are no common English equivalents. The bark is stripped off the branches and the soft fibres inside are used. These fibers are mashed up into a fine consistency and mixed with a viscous liquid squeezed from the hibiscus root **tororoaoi** in cold water. The water must be quite clean and since this has now become quite a problem for Japan, a lot of paper will be imported cheaply from Taiwan. There is virtually no difference between the two. The mulch is then sifted through a fine mesh made of small bamboo splints that are occasionally backed with pieces of silk to make an even finer mesh. The paper maker's art is in the sifting of his pulp because it is easy to tear the fiber with mishandling or finish the process with a soggy and useless lump. The largest single piece that can be made by machine is about the **zenshi** size, but bigger sizes are made for calligraphers in China. Two people work on either side of the sifting frame in that case. This means, however, that it is very difficult to control the quality and paper tends to become uneven in thickness or even have holes in it. Paper is also made by machines in which case it will be termed **kikaizuki**, machine filtered, in contrast to **tezuki**, hand filtered. If a piece of filtered paper is held up to the light watermarks are easily discerned, with hand filtered paper these watermarks are slightly irregular. Paper can be made in one's own bathtub if you are game to try. Supplies can be found occasionally at art supply stores and then you have only to be brave enough to experiment. You might consider experimenting with an airbrush and placing designs on paper with homemade stencils or perhaps maple

leaves. Place your object on to the paper and then spray colour over them so that a white silhouette is left on the paper which is ideal for **kana** works. Another idea for paper to be used with **kanji** is to make a large seal and then stamp it in red across your paper in a regular pattern rather than haphazardly prior to writing. With imagination much pleasing work can be accomplished.

Inkstone **suzuri**

Once inkstones were just that, made of stones. They were hard so that they would not wear down and were obviously impermeable. The most common material used in inkstones is slate and usually the best material is found in river beds. The range from very simple stones to extraordinary pieces found only in China like the **rakuroken** valued at more than ten million yen.

The important things to watch out for when choosing an inkstone are firstly the quality of the stone and next the grain of the stone. Colour and design are unimportant since they serve only to decorate or enhance the price that may be asked for the stone. It should neither be too light nor too shallow and the larger it is the better as it provides more freedom when rubbing your inkstick. The grain in the stone is commonly called its **me**, but more formally it is called **hobo**. There are three sorts of **me** namely, vertical, horizontal or diagonal to the inkstick when it is being rubbed. The best advice is to avoid the first two types as they may cause you to dissatisfaction because the quality of the ink sediment is bad. A vertical grain makes lots of black ink quickly, but brings too much of the glue in the ink out into your mix and will cause chunks of glue to float about in your ink. The horizontal grain will hardly make any ink at all as there is no friction. The best Japanese slate known as Genshoseki comes from Okachi near Sendai, and stones from Akamaseki are also good. Stones are often given a thin coat of varnish to make them look blacker and more attractive, but beware of this trick because it also serves to deceive the buyer as to the true quality of the stone he seeks to buy. The following are well known stones: Amahata from Yamanashi Prefecture, Ryukeiseki from Nagano Prefecture, Ramonken, popular yet cheap often with vertical **hobo**, Choteiken, a light fawn coloured stone speckled like a pear and found in the rivers of China, and Ranteiken, extremely rare and expensive, but the best available often delicately carved with intricate tunnels for the ink to run through and little or no reservoir. Other materials that may be used for grinding ink are lacquer ware **shikken**, pottery **token** or wood **mokken** surfaces.

Finally three types to avoid are are **sokotanken**, the same slate used on billiard tables and definitely the wrong grain, **neritanken**, stones made of remoulded pulverized stone which will split, chip or worse if you drop it and the rare

tankeiken, the purple stone.
There are too many **neritanken**
imitations to believe that a
novice can have found the real
material. If it is however, a
real **tankeiken** you can rest
assured because such stones
have been used since the days
of the T'ang Dynasty.

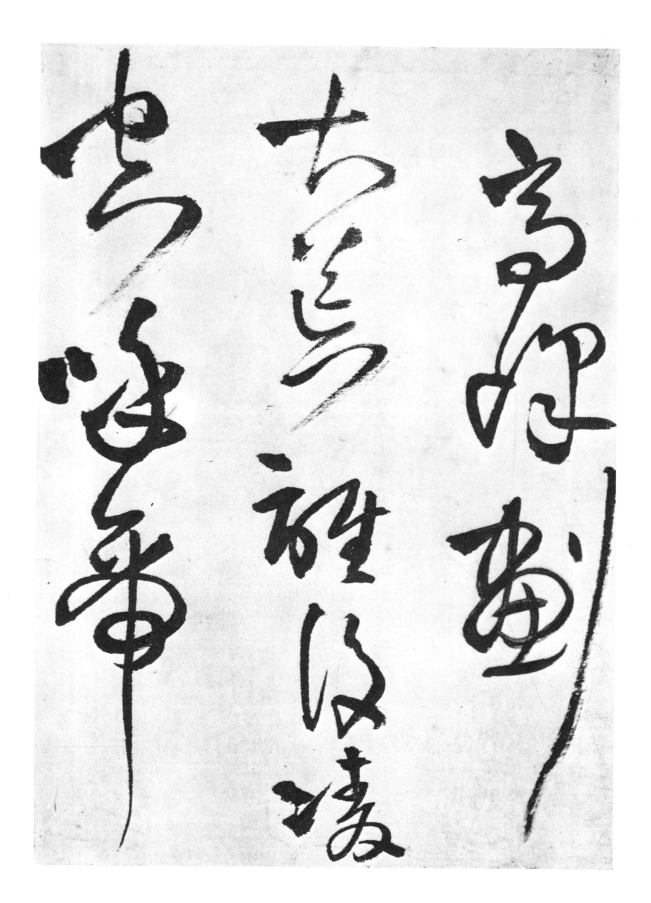

Ōgishi's sōsho

Definition of Sho

Sho is any work of art that uses **kanji** or **kana** in any form as a medium of expression using **sumi** and a brush. "A work" refers to a work of art based on the principles of **sho**. This includes **kokuji** and **tenkoku**. The question is often asked whether one paints or writes **sho** and I do not know. Perhaps it is expressed. The same question might be posed about **jūdō**. Does one play, fight or sport it?

Interviews with Famous Teachers
五十音順

Uno Sesson
Member of the Mainichi Calligraphy Exhibition Judging Committee; Professor of Calligraphy at Daito Bunka University; Head of Keisei Calligraphy School

Q: **What do you see as the fundamental difference between Western art and Oriental art, and in particular in relation to calligraphy?**

A: Different climates and terrains lead to differences in customs and life styles like sitting on the floor and sitting on chairs and the various types of housing people prefer. Calligraphy has developed as a part of the everyday life of a people, and is especially notable among crafts which have become indistinguishable from the life of the people. Nowadays it has got to the point that musuems have been established where people can go to see **sho** or other kinds of art. This is a recent trend because once it was usually on display in people's homes either in the alcoves **tokonoma** or on the opaque **fusuma** sliding doors separating rooms. This has to be a fundamental difference between the roots of Western art as opposed to Oriental art. In China the people use chairs as in the West yet **sho** was displayed in their houses. Even so their houses are constructed differently compared to Japanese houses-there is no **tokonoma** so **sho** was customarily hung on walls or used as a decoration on folding screens. In the West the development of art to be placed in museums and galleries was a much earlier phenomenon than in the Orient. In the East it was meant to be kept at home for decoration.

Q: **Recently the fude brush has become exclusively an artist's tool where once it was as common a part of life as the pencil is today. Young people these days have few opportunities to use a brush and indeed confess to having great difficulty in using it well. They cannot read Chinese style poetry or old style kanji. If this trend continues as it seems to be do you think that shodō will become an art of the elite?**

A: Things may come to this. In the old days except for the incidental everyday uses

people made of the brush, this art truly was the preserve of the elite. The best calligraphic works were by literati **bunjin** or people who were particularly well educated in the classics. A hundred and thirty years or so ago, public officials in Edo had to use a special personal type of script called **oieryū** on their public notices or in their reports. This use was regarded as part of their work and was not much different from being a signwriter today. There were also secretaries to the barons called **yūhitsu** who wrote out the final drafts of correspondence to which the overlord merely added his monogram. Calligraphy as you can see did not begin life as an art form, but was nonetheless developed by a small number of people. **Bunjin** literati not only studied **sho**, but also worked on poetry composition and the carving of seals as well. People have only recently taken up an interest in **ukiyoe** floating world art. It was regarded in Edo times as proletarian art; about as important in those days as a poster for the cinema is now. People who study poetry and **sho**, like the **bunjin** of old, are still rare. There are those who may study **sho** as an adjunct to the working class hobbies of tea ceremony or flower arranging, but it is still the case that only a few practice it exclusively as the art form it is. It has become so that people can neither read the more esoteric **sho** cursive, **ten** seal or **rei** ancient scribe's styles nor comprehend more unusual characters. People could not read **tensho** even in the Edo Period. The worry is that people may lose the ability to use a brush, since everyone now uses either pencils or ball point pens. Since the Second World War western ways of living have inveigled their way more and more into life here, particularly mealtimes. Elementary school children normally use spoons instead of chopsticks and their fingers are becoming accordingly less dextrous which leads to the difficulty they have using a brush.

Q: New forms of calligraphy have been developed in the forms of kindai shibun, shōjisu **and** zen'ei. **Do you think perhaps the old forms of** ten **or** rei **might become obsolete in the future?**

A: I do not think that styles of **kanji** will change very much; broadly speaking there are six styles, **kobun** antique, **ten** seal, **rei** scribe's, **kai**, manuscript, **gyō** semi-cursive and **sō** cursive. If there are any developments I think they may come in the area of simplification of **kai** manuscript forms. Fewer and fewer people are able to write in semi-cursive so they are forced to resort to the manuscript form for everyday needs. In Japan people can resort to the **kana** syllabary scripts for their needs, but in China the problem is particularly difficult because to indicate something so basic as the past tense of a verb, one must add another character. This played a part in the movement toward simplification that swept the land in the fifties.

Q: Recently I traveled to Hong Kong and was surprised to see that even the simplest characters were being radically reduced and what I thought were difficult characters of thirty strokes or more were still used everywhere. Surely this is not in the best interests of the people.

A: It is said that illiteracy is still very high in China and presumably authorities encourage any movement that will make it easier to learn the fundamental five hundred characters or so. Since they thought that a complicated form would not likely be used by someone like a farmer, they thought abbreviating it would cause no serious consequences. At school students learn about two thousand characters of which they may be able to read twelve hundred. The actual number they can recall well enough to commit to paper as adults is likely in the area of only four or five hundred. A problem with **sho** is just how much of the meaning a person gazing at it can understand and this led to the development of **kindai shibun**, but this is really closer to the realm of literature than **sho**. The beauty of **sho** is in the line, shape, **hitsui** inner feelings at the moment of writing and **hissei** power of the line. The appeal of **sho** has nothing to do with literary expression. If a poem has as its theme a lovely sunset, **sho** need not have the same feeling since it is a totally different representation.

Q: Does that mean it is not important to be able to read a poem in kanji, but that if the expression is good that is sufficient?

A: Yes. The two arts should be separately appreciated, neither dependent upon the other. In old times poetry was appreciated as a form of singing. Now a gothic type of graphic lettering with a uniformity in the quality of the line is becoming the standard writing style of everyday **kanji**. One has only to look at advertising copy to see this. This trend has lead to the spread of something called the printed culture **katsuji bunka** and people are so dependent upon that that they find difficulty in reading the hand written word. No wonder their appreciation of **sho** has been so diluted.

Q: The Chinese bunjin used to draw his own picture, write a poem to fit it and then put his own handmade seal on his work. Can the present day Chinese still do this?

A: The only people who can do it anymore are those who were educated before the War, people now sixty of seventy years old. These are a small elite.

Q: I have often heard it said that shodō is experiencing a small boom here what with the exhibitions and formations of interest groups. Is this the case in China?

A: It was being studied in the schools I have visited, but this may not be true of all schools. The education system in China is similar to that of Japan, a system where the pupils specialize in different subjects so that **sho** not being as important as it once was is probably dropped by the age of fifteen. The boom in Japan is due to an increase in leisure time and does not amount to an increase in the number of people who practice **sho** as a profession.

Q: It has been suggested that it might be possible to write the alphabet like sho **is written. How do think this might be achieved?**

A: That is like suggesting to a Japanese that he write **sho**, but only use the **katakana** syllabary. It would not be impossible, but the only interest would lie in the fact that no one else was doing it. If everyone wrote **sho** using this syllabary it would not be interesting in the least.

Q: Kanji has its roots in shōkeimoji **abstract symbols representing concrete ideas and forms and are therefore based mainly on pictures. The alphabet has no similar background so how would you go about abstracting it.**

A: In my abstract calligraphy I often find that there is a problem in that the simplified forms begin to all look similar. This would be a problem with the alphabet as all the letters are so similar. A, e, o and c are basically the same circular shape with only a slight variation. The same sort of problem exists not only with the alphabet, but also the syllabaries. **Kanji**, however, being complicated in shape give one the opportunity to make more variations. Complex feeling would be hard to express with such a simple medium as the alphabet.

Q: My next question may sound a bit impolite, but it has been said by some people that zen'ei **abstract calligraphy looks like something a gorilla might write and I believe you, Uno Sesson, retorted that the average person can read neither seal script nor** zen'ei sho **and that very much like saying the same thing. Would you say that this sort of attitude toward** zen'ei **is widespread?**

A: I asked the person who wrote that remark whether or not he had ever tried getting a gorilla to write calligraphy and that if he had not that perhaps he ought not to say such things. He apologised to me and said that he was not referring to my work, but to some zen'ei artists. The French artist Matisse visited Japan once. At the time a dancing sect of Buddhism was common and in this sect everyone would dance himself into a trance thereby achieving a form of unified spirit **seishin tōitsu**. In

America they have action painting and this again is similar. **Zen'ei** is the same in so much as a person first concentrates all his powers and then releases them in the few seconds he writes the **sho.** Whoever it is, a state of **muga** consciousness is reached in which one achieves perfect selflessness and everything else is forgotten. It becomes a marathon fight within the person. The spirit is agitated and quite excited. He needs a special mentality to continue at this high pitch and still remain flexible. He becomes so engrossed that he forgets himself and people might think him quite mad.

Q: Some zen'ei **works are large circles, like doughnuts, that seem to concentrate on the tone of the ink, harmony of composition and use of the white space** kūkan. **I have often thought that the hardest thing about the work must have been thinking up the seemingly unrelated titles people give these works.**

A: Normally in writing calligraphy one used a poem for the contents **monku** and so the title is decided for you, "such and such person's poem written on such and such occasion." Thus a title is really the name of the materials that are being used. This is no different from a book title. Most **sho** titles therefore are based on literature. In **zen'ei** people will use the date of their birth and straight forward numbering and in most cases the titles are written in roman letters rather than in Japanese because if this were written in **kanji** it would often be mistaken for the cotnet of the work rather than its title. Normally the titles will be abstract ideas themselves such as "void", "nothingness" or "death." The character for void can also be interpreted as sky and this automatically conjures up images of sunsets, autumn skies or something of the like, whereas "void" is a philosophical term that does not interfere with the expression of **sho.** "Nothingness" **Mu** can be used to counterbalance "something" **Yū.** I was once asked by a writer how I chose the names of my works when they did not at all appear to resemble the things I had written and I replied by asking him how he went about choosing a name for his child. I asked if he thought that by calling his daughter **Michiko,** beautiful child of wisdom, that she would grow up to be intelligent? Did he think he was matching the name to his daughter's character when she was not even one year old? An artist's work is like a child. He cannot expect the title to be an exact representation of the contents particularly since every person has a private experience when he views a work and no two experiences would be exactly the same.

Q: If the contents, title and even sho **are abstract then should not the seal** inkan **be so also to complete the picture so to speak?**

A: At present hardly anyone has gone quite that far because everyone seems to prefer to observe the convention that in the old days Chinese **bunjin** used to carve their own seals, and use **tensho** seal script for that purpose. Everyone recognizes that **gyōsho** the semi-cursive script does not work so well for this purpose. At any rate the seal represents the artist and he sees that seal as a part of himself. If he matched the seal to the work he would be forced to make a different seal for every one of his works. So unless there is some drastic change in the attitude toward seals, then matching the seal to the work will remain a rather difficult problem.

Q: Zen'ei **seems to be very similar to what was done in Europe ten of fifteen years ago except that it is limited to one colour. In 1979 I saw two of your works in the Hachinin Ten at a Ginza department store. One was flight** hi **and to me it looked like birds in flight. The other crossing** kō **I did not understand at all. You wrote it as two crosses one on top of the other, well separated with a smaller cross between the two. Could you explain what you were attempting in this work?**

A: This was the antique **kobun** form of the verb "to cross." The challenge as I saw it was how to introduce rhythm into three crosses, like a three part movement involving flight. It was a construction problem in how to represent this rhythm. I used the technique of ink colour, a heavy dark cross, a small variegated cross and a third big black cross. The character had to be vertical, too, which made it more difficult. This sort of **zen'ei** is constructed on a theoretical basis using the old characters as precedents. But I feel the large circles are straying too far away from **shodō**. The only thing it has in common with the traditional art is that the materials being used are the same, paper **washi**, the inkstick **sumi** and the brushes **fude.**

115

Kaneko Ōtei
Adviser to the Nitten Calligraphy Exhibition; Trustee of the Mainichi Calligraphy Exhibition; Director of the Sogen School of Calligraphy

Q: What is the difference between calligraphy, "beautiful writing" in the western sense of the term, and sho?

A: Anything without rhythm cannot be **sho**. In calligraphy colours may be painted in and a ruler used to make corrections, but you cannot do this in **sho** so in this sense it is like a ballet movement which cannot be redone. **Sho** is an art that incorporates both time and space with something left over afterwards. The **ukiyo** floating world pictures of old Japan greatly influenced the impressionist movement in France as did Japanese line and construction. At that time the line became a major element within the picture. European art had been largely of plane construction and coloured; lines per se did not play an important role until drawing, **dessin** became so popular. The line was a major factor in the artistic revolution. This line was the same dynamic line used in **shodō**.

Q: Would you say an important difference between the line in Western art and Japanese art is the difference between a dot and a line?

A: The roots of art in Japan, the West and China are basically the same. The difference, I feel, is that the west has been blessed with natural resources so it has been easy for the western races to live and develop economically. Oriental countries, on the other hand, have had to live in much more severe circumstances so that accounts for the difference.

Q: Present day calligraphy depends in large part upon the beauty of line and harmony and in the case of kindai shibun upon the reading of the poem. Do you think this trend may lead to the death of the classic ten, rei, kai scripts?

A: No...

Q: But would you not agree the people looking at the works cannot appreciate them?

A: Let me put it this way. If you draw a horizontal line it has a feeling of peacefulness, quiet and femininity, but a vertical line for its part will have a feeling of exertion, aggressiveness and suffering. Every race in the world has similar feelings toward the geometric line. The feeling is a natural thing they have experienced in childhood. The point is even if the viewer cannot read a character, he will sense if the balance is bad that something is wrong. This feeling toward a line is

116

the same anywhere in the world. If this sort of an interest in the line is nutured, then **ten** or **rei** classic scripts will endure. Ancient masters of calligraphy has great difficulty maintaining the quality of their line, but that was not their primary object. Their function was the recording of the important events of the day and this is something like what we are doing today with **kindai shibun**, recording the language of our day.

Q: If one does not understand the meanings of the characters do they not just become materials? Surely if young people do not understand these materials they cannot use them.

A: Perhaps your view is a little narrow. Even **hiragana** syllabary at a simple level can be artistic. If you tried writing the alphabet in large letters you would succeed in accomplishing the same thing I am sure. **Sho** should be thought of as an abstract art which uses the beauty and power of a simple line.

Q: Kaneko Sensei, you suggest that the alphabet could be used to produce something like sho. Could you elaborate on this a bit? Kanji **characters were originally little pictures, but the alphabet does not have roots extending back to** shōkeimoji **like this so would you not say that it would be difficult to express oneself with just letters? If one were to attempt something**

like this it seems to me that it would be impossible to feel anything by just looking at them.

A: Oriental characters, of course, can stand independently as they have a meaning. The alphabet is the equivalent of our **hiragana** or **katakana** syllabaries; they express only sounds. The alphabet could be used to show the beauty of a line and could incorporate rhythms. Rather than use many letters a person might employ only a few well chosen letters with more telling effect. The more you study the more you will reach a point where by drawing just a single line you will be able to convey a feeling of infinity. Even the "i" of the **iroha** poem or the "a" of the alphabet may express and capture on paper a feeling of infinity. This may be done by varying the depth, speed and changes of pressure in the work. There is a story about Achilles that illustrates what I am trying to explain. Achilles had left Greece to visit another country and Protogenes a friend of his, appeared at his home one day expecting to find him. Protogenes was disappointed at missing Achilles and asked for writing materials with which to leave a message. Without saying who he was, he left an unsigned message consisting of a single line which he directed be given to Achilles on his return. When Achilles returned and was given the "letter" to read, he knew instantly it was from his friend Protogenes. What I mean by this story is that just because something is simple it does not necessarily

117

mean that it has no meaning. If you were to use the alphabet for a **sho** work it would have to be abstract. You might get a hint from looking at the **ten** and **rei** forms and then write just a few large characters.

Q: **The famous impressionist poet Guy d'Appolinaire wrote the words of his poems so that they formed a simple picture. Some people would be reminded of this by any attempts to marry** sho **and the alphabet.**

A: That is certainly one means of bringing the alphabet to life. It is, however, dependent upon the meaning and makes the beauty of the shape of the letters unimportant. That is why an abstract approach enables one to use various subtle changes in the quality of line allowing for greater freedom of expression. This is how **kanji** are used as tools or a means for studying a line.

Q: **If we open a calligraphy dictionary today we can see there are many historical examples of characters. There are no similar historical background for the letters of the alphabet as an art form. Also many people feel that if one departs from the use of** kanji **as the manifestation of a line form somewhat like the Zen'ei school is doing that the result is no longer calligraphy, but only abstract art making use of** sumi **ink. How do you react to this argument?**

A: All art when it comes right down to the fundamentals is based on a line much like the cell is the building block of all life. As one develops in the quality of the line allowing for greater freedom of expression. This is how **kanji** are used as tools or a means for studying a line.

Q: **If we open a calligraphy dictionary today we can see there are many historical examples of characters. There is no similar historical background for the letters of the alphabet as an art form. Also many people feel that if one departs from the use of** kanji **as the manifestation of a line form somewhat like the Zen'ei school is doing that the result is no longer calligraphy, but only abstract art making use of** sumi **ink. How do you react to this argument?**

A: All art when it comes right down to the fundamentals is based on a line much like the cell is the building block of all life. As one develops in his artistic style along a certain direction he may eventually meet a developing style of some other art coming from the opposite direction. That is art. Use **kanji** as a medium for learning the beauty of a line and express this with your alphabet. You will eventually produce abstract works that are virtually one and the same as abstract **kanji**. The beauty of **sho** is in the line.

Chō Yōseki
Member of the Judging Committee of the Mainichi Calligraphy Exhibition; Director of the Japan Carved Calligraphy Association

Q: What are the fundamental differences between Japanese art and Western art, in particular calligraphy?

A: When calligraphy is shown to foreigners they do not generally understand it. All they see is the black, white and the balance. The methods of expression in painting and sculpture are obvious because they originated in the West. Besides that those art forms have been supported for such a long time by wealthy benefactors or perhaps even governments so that famous artists have not had to suffer. In Japan the overall scale of art is smaller than that. Seal carving **tenkoku** and carved calligraphy **kokuji** are more popular among westerners than pure calligraphy **sho** because they can see with those arts that a lot of effort has gone into them, but **sho** is completed in a matter of seconds so the uninitiated cannot really appreciate the degree of difficulty that is involved. **Zen'ei**, the avant garde art form of **sho** has it similarities with abstract forms of western art, but still those who are interested in those forms assert their interest is more in the materials and tools being used and they are less interested in the actual art itself because they think they could

do just as well as their Japanese counterparts. Calligraphy has to be well explained if Westerners are going to appreciate it so for that reason abstract forms **shōkeimoji** of the ideographs are popular as they are easy to comprehend visually and they are expressed using oriental techniques and materials. The work is executed in the space of a moment, but this can only be done after twenty or thirty years of practice.

Q: Young people are no longer able to read the old forms of characters or kanbun **Chinese forms of the Japanese language so why is it that they go to exhibitions when they can only partially appreciate the works?**

A: Before World War II the philosophy was that if you could not understand the poem, you did not write it: we used to study **kanbun** and write our own compositions in **sho** and rarely ever resorted to the Anthology of Chinese Poems **Bokujō Hikkei**. Nowadays the emphasis has shifted to art for exhibitions, **kaijō geijutsu**, and the original reasons for calligraphy have been lost. Not only that, but the art itself for a time was being pretty much overlooked. Thanks to the efforts of today's leading teachers it is experiencing a strong revival. Nevertheless because of the **kaijō geijutsu** mentality the necessity for being able to read characters is being overshadowed in favor of the notions of harmony and feeling. In that respect **sho** is viewed very differently

than it was in the old days.

Q: The seal scripts ten **,** rei **scribe styles,** kai **the manuscript forms, semi-cursive forms** gyō **and the grass style** so **are regarded as the classic modes and the** kindai shibun, **Modern Poetry Movement,** zen'ei, **Abstract Calligraphy,** shōjisu, **Single Character Calligraphy,** and kana **syllabary styles are also very popular, but do you think that in time the classic styles will fall into disuse and one day leave only forms that no one can read?**

A: It can be said that there is such a trend, but conversely it may also be that that is because new artists are appearing and that their emphasis is on new and easy to understand expressions instead of the old, staid **kanbun** or classic **sho** styles. In our eyes the standards have fallen. **Shōjisu**, for example, is easy to practise and appreciate. The inspiration for **kindai shibun** was so that people could read the works, but today that is no longer true. In Ogishi's day the modern form was **gyōsho** and **reisho** and **tensho** were largely ignored as being out of date, but in the long term they have survived. Likewise **sho** will survive. There are possibilities that new scripts will be born and that is the challenge.

Naruse Eizan
A Member of the Nitten
Calligraphy Exhibition;
Permanent Director of the
Kenshin School of Calligraphy

Q: I suppose the importance
in creating compositions
sōsaku , is always looking for
something new.

A: Yes, but you paint with
your feelings and you do not
know what your feeling might
be until you come to write.
Shodō is not an artisan's
craft like carpentry. You
cannot knock something
together on order. A house is
built to be lived in first and
looked at second. **Shodō** is to
look at. **Shodō** at the lowest
level is in the writing more
than the display of something
a carpenter has put together.
The problem is more how the
work is related to life. A
person who just views the
works might comment on them,
but it really takes a person
who is a calligrapher himself
to appreciate a work properly.
Then a desire to try something
different wells up in you.
The creative life is not all
fun and games. There is a lot
of anguish and some people
never find satisfaction or
enjoyment even if they are
doing what they want to do.

Q: What do you feel to be the
fundamental differences
between Oriental and Western
art?

A: The difference is in the
substance. The difference in

customs, climate and country.
Even among Orientals, the
Japanese and Chinese think
differently. In fact the Chi-
nese may have thought patterns
nearer to the Westerner than a
Japanese. Chinese are brought
up on the continent of Asia
and many have never seen the
ocean, but Japan is an island
nation. This may have an ef-
fect on the respective Chinese
and Japanese feelings toward
art. China is the country
where **kanji** was born and so
any serious study must include
the study of the Chinese ori-
gins of **kanji**, but the use of
kanji as an art form in China
is not as advanced as it is in
Japan.

Q: **Sometimes calligraphers
use only half a poem for a
work and so can we then say
they are using the characters
as something decorative rather
than literary? If so is the
meaning that important?**

A: Strictly speaking poems
are the materials used for
sho. The object is to exhibit
one's power of expression
through **sho** using the poem as
one's medium. If one wants to
study poetry, one should buy a
book. **Bunjin** who wrote poems
illustrated them and wrote
them in their own **sho** were
primarily poets expressing
their poems through **sho.**
Calligraphers express their
sho through poetry. The
material to be used for **sho**
need not necessarily be a
poem, but **sho** relies on **kanji**
for its expression and **kanji**
were invented so that people
could write whether that
writing be a poem or whatever.

This may be why people usually choose pieces of literature for their **sho.** Normally they enoy or admire the poetry so that is why they choose it.

Q: Does this mean then that the meaning is not important so long as it is a character?

A: I would not go so far as to say that, but it is possible to use **kanji** outside the framework of a poem.

Q: How about the mixture of kana and kanji chowatai?

A: It is very difficult to mix **kanji** and **kana** because originally they were not intended to be mixed. **Kanji** are very active, expressive and strong, but **kana** lacks that power. Even though **gyōsho** and **sōsho** are often mixed, **chōwatai** is an extremely difficult medium to express oneself with.

Q: What do you think of abstract calligraphy zen'ei?

A: Basically it is copying Western artists. The philosophy behind it, however, is very complicated. It is in the front line of calligraphy searching for new frontiers because it has rejected the accepted traditions and found a new way for itself. Its artists each have their own

theories. By studying historical works it gives them ideas of what is different from the ordinary, in other words they have to diversify into new areas of expression.

Q: So do you think this is the future of shodō, new ideas replacing the old, especially since the young generation has no particular interest in classical kanbun **and has difficulty in even using a brush?**

A: **Shodō** is not a rational thing so as the need to record ideas more accurately develops and with it computers and calculators, the art is likely to move further from the average person's life and become a more and more erudite art form. But there will always be a need to express one's feelings, mechanical objects cannot do this. When you write **sho** you are portraying yourself on paper.

Q: At an exhibition in Paris in which you participated, the catch phrase used in the publicity was that calligraphy is the art of time and space. Could you explain what was meant by this?

A: By time what is meant is the rhythm inherent in the **kanji** because it has great influence not only on the expression, but on the work as a whole. It can also be explained as the capturing of a feeling at a time and the

experience of that moment on paper. Space is a balancing relationship between lines that go in to make up a character, and then one character to the other, and finally the whole to the frame or the space available in the frame. The tea ceremony is an experience in the art of time also, but the tea ceremony teaches more in the way of etiquette than art. The same relationship exists between **shūji**, learning characters, and **shodō**, conceiving one's own compositions. one is in the learning, the other in putting into practice what one has learned.

Q: How do you suggest a person might best go about developing his own form of expression through sho?

A: That is very much an individual decision, but I think it is important not to be unduly influenced by other people's opinions and follow instead your own feelings. Another important point is to become familiar with the Chinese classics, not just their content, but the grammar and history as well. Thirdly, one must learn the language, be it Chinese or Japanese, for the reason that one cannot fully understand another country's culture and there-fore the spirit and feelings of the people who wrote these characters without speaking their language. I guess that goes without saying since all the texts are either in Japanese or Chinese.

An appraisal of a work in the author's collection-

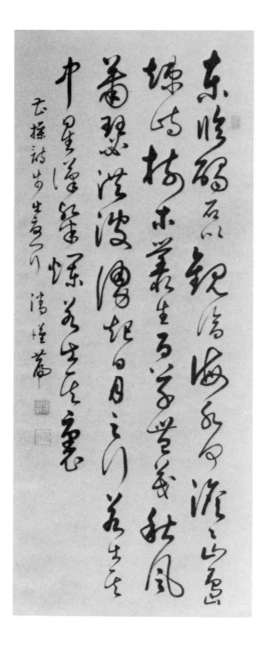

The calligraphy in this picture is done in the **sōsho** cursive style and is composed of twelve sets of four characters though this is not apparent just by looking at it. It is called **Sōsōshi.**

曹操詩

I will attempt to describe the work in three steps: a quick glance, a good look and a close examination and by those steps perhaps I can convey a bit of the allure of calligraphy.

The first look-a quick glance: Three and three quarters lines signed with a complementary pair of **in** seals mounted on a **kakejiku** scroll done in **sumi** ink on brown paper in the **sōsho** cursive style.

The second look-a good look: Referring to the points at the beginning; lines are curved, but rather than delicacy there is a great deal of action, this is evident in the sharp tails and the **kasure** ink traces at the end of the characters. The tone of the ink is consistent throughout and the pulse is a strong one with heavy characters leading into weaker and delicate ones. A summation of this work would go something like: confident brushwork, good balance, but the juxtaposition of characters from one row to the neighboring row is only fair to middling. There is a great deal of movement and vigour which might lead a Japanese critic to say it has dexterity **takumi .** Visually it reminds one of the carnival in Rio, but with less noise.

The third look-the close examination: First row, sixth and seventh characters; **kan,** a powerful, straight **hen** with a leisurely and graceful **tsukuri**, the tail with its hook is fabulous because it leads to the small, but cocky 滄 . The first row, however, is slightly cramped at the bottom. This feeling is under-

124

lined by the great weight of the character pressing down from above. Second row, first and second characters; the hook departing from the **hen** and followed by the powerful downstroke and graceful, sweeping movement resemble an acrobat who appears to have been given a push to continue into his motions straight into 山寺 . Second row, eight, ninth and tenth characters; the movement begins in 草 somewhat like a spring. If the poem had stopped here, one might argue that the left **ten** of the **kusakanmuri** was too far to the left, but the explosive motion of its spring back into 豊 pulls the character back into line and with three hops of a chaffinch on a spring morn we are back off again into the tight, but beautifully structured and balanced 茂 . It is poised and only held back by a perfectly positioned dot **ten** holding it with gossamer spider's threads. But how about the second row, last two characters? 秋風 "Autumn wind." In autumn I perceive tongues of fire leaping skyward and the warmth of the connecting stroke, neither too dark, (heavy or black) nor too light (cool or bright), but a medium warm brown, russet or orange colour. The tail "a picture of the wind" is echoed above and to the left in 行 . Just as the autumn wind changes direction with gusts from all sides, so too does the character for "wind" with its tail seeming to cast up a handful of leaves. In row three the fervour of the artist seems to have gotten the better of him. I feel that the fourth and fifth characters should be decreased so that more room is left for expansion in the fourth row particularly at characters four and five. The last eight characters in row three, however, are incomparable. Row four the first character seems strangely out of place. The left stroke is normally vertical rather than a horizontally written diagonal. This is distracting and once noticed tends to stand out badly. Nevertheless there is so much going on what with autumn winds of fire, chaffinches, acrobats and exploding clocks and so forth that who would really notice this slip. Line four seems to have been cramped in if only to provide room for the **rakkan** dedication and there is a certain hesitancy about the fifth character. The **hen** is a little bit too far to the left and seems a bit lonely.

Still all in all it is a marvellous piece of calligraphy and what a story! We do not even know what the poem is about, but if one can feel that much about it without even knowing the content, surely it compares to any technicolour epic which might unfold before my eyes.

Now when I study a landscape by Constable, for example, I am told a lot by the title and everything else by the photographic accuracy with which the real thing has been portrayed. My mind one, admires the detail and the accuracy of colour and two, finds diversion by conjecturing what might happen if the cow in the field wandered down the lane. Everything has been explained to me in great detail, whereas in this **kakejiku** scroll nothing has even the poetry is stark; but

at least it provided a private experience and it lives for me. Also it is different for everyone, perhaps you thought the last few paragraphs have been the ramblings of a madman or perhaps rather than an acrobat you saw the tip of a fencer's epee tracing in the dark. An actual rendering of the meaning of the poem is something along these lines:

A man climbs up a mountain and sees the sea stretching out far below him. The waves are bobbing up and down and an island seems to be floating in the sea; there are trees on the island and plentiful green grass. An autumn wind gusts suddenly and lifts the tips of the waves. The sun and the moon seem to rise out of these very seas from whence the Milky Way originates.

Some peculiarities of Chinese Writing

A Chinese character, evolved as it was from a picture, displayed its meaning clearly to a cognizant observer through its appearance, but the phonetic system of the language being what it was-a monosyllabic maze, countless homonyms developed and this tended to cause a great deal of misunderstanding. This state of affairs led to the introduction of a tonal system, but not even that was to prevent the formation of an even formidable obstruction. These same symbols have constituted a considerable barrier to education and the spread of literacy. At even the most rudimentary level, the form and pronunciation of more than a thousand characters must be learnt.

Characters, however, for all that may be said against them, have given a country which possesses half a dozen major and numerous minor dialects a cultural unity because characters have the same meaning no matter what the dialect.

Reisho

127

A few facts about KANJI

(A) **Kakijun** sometimes called **hitsujun,** the stroke order:
The two main rules are that firstly you start at the top and go to the bottom and secondly write from left to right. For example:

The numbers represent the position the brush starts and you can see by the position of the numbers that they follow the rule, top to bottom and left to right. So in the case of **GEN** five and six start in the same position, but five is a top to bottom stroke and has priority as in **KYŪ** three is nearer the left than four so it is written first. Like every rule there are exceptions:

The importance of a correct stroke order comes into play when you attempt to write in **gyōsho** or **sōsho** since the lines are often connected together. If the order is wrong then the lines will be in the wrong order and not only will the character be incorrect, but it may also be read as something else altogether. Look up the order in your dictionary before you start is the golden rule.

(B) Characters for Daily Use

The following three terms are often referred to and easily confused: **tōyō kanji, jōyō kanji** and **kyōiku kanji.**

Tōyō kanji: The Japanese government in order to raise their educational standard decreed in 1946 that only 1,850 charcters would be used by schools, newspapers, in laws and public notices. These

128

had been selected for their frequency and supplemented by another ninety-two to be used exclusively in proper names **jinmeiji**. The remaining characters, six thousand or so, could be written by the calligraphers and scholars.

Jōyō kanji: The earlier ordinance having to do with the limitation of characters had at first only been regarded as a temporary measure so there were in fact several anomalies. In 1981 therefore, the list of **kanji** was expanded to 1,945 characters, useless characters deleted and **jinmeiji** increased to one hundred sixty-six. The total included many abbreviated forms of characters that were widely used by the populace anyway.

萬→万 圓→円 佛→仏 當→当

Kyōiku kanji: designates 996 of the Joyo Kanji which are to be learned during the first six years of compulsory schooling or by the time a student is twelve years of age. There are 76 in grade one, 145 in grade two, 195 in grades three, four and five and 190 in grade six. The remainder of that 1,945 are learned by the time a student is fifteen and theoretically finished with his schooling.

(C) MONOGRAMS Kaō 花押

This symbols were first developed during the Heian Period (794 - 1185) and gained much popularity during the Tokugawa Period (1600 - 1868). They were used in place of seals or the final signatures on official documents or letters. From the Meiji Restoration (1868) the official registered seal system became legal so the use of monograms went out of fashion.

Ashikaga Takauji
(1305-1358)

Oda Nobunaga
(1534-1582)

Tokugawa Ieyasu
(1543-1616)

(D) Graphology

The form of a character to be used can be an indication of the respect another person intends to show. The character 殿 **dono** for example normally used to indicate "Mr." on letters has varying forms:

To a person superior **meue** to you

To a person of similar position **taitō**

To a person inferior **meshita** to you

Eiji Happō 永字八法

By practising this single character it is possible to exercise the eight major strokes of calligraphy. Each stroke has its individual name.

The character **EI** is "eternal" in English.

1. SOKU	側	5. SAKU	策
2. ROKU	勒	6. RYŌ	掠
3. DO	努	7. TAKU	啄
4. YAKU	趯	8. TAKU	磔

Soku: The brush enters from the northwest and stops briefly before pulling off to the southwest. It is important that the corner is a square angle and not curved.

Roku: This basic stroke is often referred to as a bamboo stroke as it should look when completed like bamboo. Pressure is applied as the brush first touches the paper and this pressure is released a bit as the brush crosses the paper and then reapplied at the end of the stroke. The stroke should not be horizontal, but rise an angle of five to ten degrees.

Do: The brush is firstly placed on the paper with pressure and this pressure is gradually released as the brush is drawn toward yourself. This is done not by moving the arm, but by a wrist action so that the tip of the brush is brought toward your body.

Yaku: The pressure is reapplied and released quickly as the brush is brought off to the left to the northwest.

Saku: The brush is put down with force in the southwest and drawn to the northeast with the tip of the brush following the top of the stroke, not however through the middle as in **Do.**

Ryō: The pressure on the brush should be released slowly as the brush is pulled to the southwest and should not cease at the end of the stroke, but carry on through the air to impart a thin tail that disappears naturally.

Taku: Different from **Ryō** in as much as it does not leave the paper, the pressure is more even overall and the stroke generally tends to be shorter. It is important to have a good entry with this stroke.

Taku: This is one of the hardest strokes of the eight fundamental strokes as the pressure and the direction changes near the end. The stroke starts in the northwest and pressure is increased as the brush travels to the southeast. At a given point the brush is turned eastward and pressure quickly released so that a very open angle is formed with a bulge at the place where the most pressure was applied. The tip of the brush should follow the top of the stroke to do the stroke with any success.

131

The **stroke order**: The character **EI** is written in five strokes, but here eight have been shown for the reason that strokes 2,3 and 4 (**roku, do,** and **yaku**) are written in one movement without a brush lift. This is similar for strokes 5 and 6 (**saku** and **ryō**).

Greetings:

Greetings can be roughly divided into five groups, those for happy occasions and sad occasions, those for sending just a card and those for sending money or a present.

Cards for Happy Occasions:

Happy Birthday	お誕生日おめでとうございます
Happy New Year	新年明けましておめでとうございます
Happy New Year (**Kinga Shinnen**)	謹賀新年
Happy New Year (**Gashō**)	賀正
Happy New Year (**Geishun**)	迎春
Ushi (Zodiac for 1985 cf. **Rakkanbun**)	丑
Happy Christmas	クリスマスおめでとうございます
Wedding Congratulations	御結婚おめでとうございます
Natal Congratulations	御出産おめでとうございます
Thank you	有難うございます
A Summer Greeting at the height of the hot season asking after one's well being	暑中お見舞い申し上げます

Sad Occasions

Sent when someone is ill	病気お見舞い申し上げます
Message of Bereavement	謹んでお悔やみ申し上げます

Envelopes or Wrapping Paper

Happy Occasions: The envelope or wrapping paper should be decorated as shown at left. In the top right hand corner write **noshi**. This accounts for the name of this envelope, **noshibukuro** and for the wrapping paper, **noshigami.** The lines across the centre and the bow should be in red for a happy occasion. Above the bow the greeting is written and below your name. There will be money inside if this is an envelope and a present inside if it is just simple wrapping paper.

A Thank you gift	お礼
A congratulatory gift (Birthdays, weddings)	お祝
When the recipient is ill	お見舞
A mid year gift (July)	お中元
A year end gift (December)	お歳暮
A token of appreciation	寸志

Sad Occasions (Black trimmings)

At someone's death	御香典
As above	御霊前

133

The seasons

Japanese	春	夏	秋	冬
	Haru	Natsu	Aki	Fuyu
English				
	Spring	Summer	Autumn	Winter
Chinese				
	青陽	朱明	白蔵	玄英
	Seiyō	Shumei	Hakuzō	Genei
	蒼天	旱天	旻天	上天
	Sōten	Kanten	Hinten	Jōten

The months

English

Jan	Feb	Mar	Apr	May	June
一月	二月	三月	四月	五月	六月

Japanese

睦月	如月	弥生	卯月	皐月	水無月
Mutsuki	Kisaragi	Yayoi	Utsuki	Satsuki	Minazuki

Chinese

孟春	仲春	季春	孟夏	仲夏	季夏
Mōshun	Chūshun	Kishun	Mōka	Chūka	Kika

English

July	Aug	Sept	Oct	Nov	Dec
七月	八月	九月	十月	十一月	十二月

Japanese

文月	葉月	長月	神無月	霜月	師走
Fumitsuki	Hatsuki	Nagatsuki	Kannazuki	Shimotsuki	Shiwasu

Chinese

孟秋	仲秋	季秋	孟冬	仲冬	季冬
Mōshū	Chūshū	Kishū	Mōtō	Chūtō	Kitō

Days of the Month

Japanese	1 - 10	11 - 20	21 - 31
	上旬 Jōjun	中旬 Chūjun	下旬 Gejun
	初旬 Shojun	仲旬 Chūjun	念旬 Nenjun
Chinese	上浣 Jōkan	中浣 Chūkan	下浣 Gekan
	上澣 Jōkan	中澣 Chūkan	下澣 Gekan

Special Names for a Person's Age

Fifteen	Shigaku	志学	
Twenty	Jyakkan	弱冠	
Thirty	Jiritsu	而立	
Forty	Fuwaku	不惑	
Fifty	Chimei	知命	
Sixty	Jijun	耳順	
Sixty-one	Kakō	華甲	
Seventy	Jūshin, Koki	従心	古稀
Seventy-seven	Kiju	喜寿	
Eighty-eight	Beiju	米寿	
One Hundred	Hakuju	白寿	

Chinese	Japanese	English	Chinese	Japanese	English
丹 麦	丁 抹	Denmark	凡 庫 非	晩 香 坡	Vancouver
巴 西	伯 剌 西 彌	Brazil	日 内 瓦	寿 府	Geneva
比 利 時	白 耳 義	Belgium	巴 犂	巴 里	Paris
加 拿 大	加 奈 陀	Canada	米 蘭	末 蘭	Milan
印 度	印 度	India	柏 林	伯 林	Berlin
西 班 牙	西 班 牙	Spain	里 昻	里 昻	Lyons
希 鼠	希 鼠	Greece	阿 典	雅 典	Athens
芬 蘭	芬 蘭	Finland	孟 買	孟 買	Bombay
法 蘭 西	佛 蘭 西	France	馬 得 里	馬 德 里	Madrid
美 利 堅	亜 米 利 加	America	馬 塞 拉 斯	馬 身 塞	Marseilles
英 吉 利	英 吉 利	England	紐 約	紐 育	New York
俄 羅 斯	露 西 亜	Russia	倫 敦	倫 敦	London
郡 威	諾 威	Norway	莫 斯 科	莫 斯 科	Moscow
荷 蘭	和 蘭	Holland	華 盛 頓	華 盛 頓	Washington
意 太 利	伊 太 利	Italy	羅 馬	羅 馬	Rome
瑞 士	瑞 西	Switzerland	聖 佛 蘭 西 斯 科	桑 港	San Francisco
瑞 典	瑞 典	Sweden	維 也 納	維 也 納	Vienna
德 意 志	獨 逸	Germany	漢 堡	漢 堡	Hamburg

Rakkanbun, Dedications 落款文

Rakkan is an abbreviation for rakusei no kanshi or the few words used to complete a work, the lines written at the very end of a work including the seals. The contents may include 1) the writer's name, 2) his pen name, 3) when the calligraphy was written, either the date, (Autumn 1985) or the occasion (On seeing a pheasant rise from cover on my first hunt) or on the occasion of one's sixtieth birthday, 4) whose poem was used or its title or 5) whose work was used as one's tehon model or a combination of any of these.

In 1 and 2 the name will be used followed by sho 書 often written in the sōsho 소 form. In a kana work kaku will be added and written in kana. On occasion the kanji "rin" 臨 will be used in place of sho to indicate the work is a copy of a famous work.

The Year: Instead of writing the year according to the Gregorian calendar, i.e. 1985, the following system is observed. Until 1873 the Japanese used a lunar calendar of Chinese origin which was based on the Chinese philosophical concepts of jikkan, jūnishi. These two ideas form an array of sixty permutations which may be used to designate any one year in the cycle of sixty. The principle is that one of the branches

136

will be put side by side with one of the stems and the combination thus formed is the name of the year. The **jikkan** are the ten trunks-also known by the Japanese name **eto**, and the **jūnishi** are the twelve branches each of which is represented by an animal in the Chinese zodiac.

Year names can be used either in a **rakkan** or as an **inbun** written perhaps as "ITCHU" 1985 or "KIMI" for 1953. To calculate the year in Chinese for any year in the western calendar, first determine the **jikkan**: Divide the year by ten. That will give a sum and a small remainder. The remainder gives the clue as to the the trunk (1953 divided by 10 = 195 + 3; third trunk = KI). To determine the **jūnishi** divide the year by twelve and the remainder will provide the hint as to the stem (1953 divided by 12 = 162 + 9; therefore 1953 is KIMI). As a general rule the Japanese form of year names, months and seasons are reserved for use on **kana** works and the Chinese names for **kanji** works.

The Sixty Year Cycle

1984	1985	1986	1987	1988	1989	1990	1991	1992	1993
甲子	乙丑	丙寅	丁卯	戊辰	己巳	庚午	辛未	壬申	癸酉

1994	1995	1996	1997	1998	1999	2000	2001	2002	2003
甲戌	乙亥	丙子	丁丑	戊寅	己卯	庚辰	辛巳	壬午	癸未

2004	2005	2006	2007	2008	2009	2010	2011	2012	2013
甲申	乙酉	丙戌	丁亥	戊子	己丑	庚寅	辛卯	壬辰	癸巳

2014	2015	2016	2017	2018	2019	2020	2021	2022	2023
甲午	乙未	丙申	丁酉	戊戌	己亥	庚子	辛丑	壬寅	癸卯

2024	2025	2026	2027	2028	2029	2030	2031	2032	2033
甲辰	乙巳	丙午	丁未	戊申	己酉	庚戌	辛亥	壬子	癸丑

2034	2035	2036	2037	2038	2039	2040	2041	2042	2043
甲寅	乙卯	丙辰	丁巳	戊午	己未	庚申	辛酉	壬戌	癸亥

Therefore 1984 would be pronounced "kōshi" in the Chinese system and "kinoe ne" in the Japanese.

Twelve Stems - Jūnishi

	1	2	3	4	5	6	7	8	9	10	11	12
Chinese character	酉	戌	亥	子	丑	寅	卯	辰	巳	午	未	申
Pronunciation	yū	jutsu	kai	shi	chū	in	bō	shin	shi	go	bi	shin
Japanese Zodiac	tori	inu	i	ne	ushi	tora	u	tatsu	mi	uma	hitsuji	saru
Animal name	cock	dog	boar	rat	ox	tiger	hare	dragon	snake	horse	sheep	monkey

n.b. When the Japanese recite the Junishi they start with the 'rat' first, the table has been given in this form to make it easier to calculate past dates.

Ten Trunks - Jikkan

	1	2	3	4	5	6	7	8	9	10
Chinese character	辛	壬	癸	甲	乙	丙	丁	戊	己	庚
Pronunciation	shin	jin	ki	kō	otsu	hei	tei	bo	ki	kō
Japanese "Eto" element	metal	water		wood		fire		earth		metal
Ying or Yang	金 弟	水 兄	水 弟	木 兄	木 弟	火 兄	火 弟	土 兄	土 弟	金 兄
Pronunciation	kanoto	mizu no e	mizu no to	kinoe	kinoto	hinoe	hinoto	tsuchi no e	tsuchi no to	kanoe

138

How to write your name Ateji

A more favoured way of writing your name is by determining a set of **kanji** that may be used for their sound value only. These are called **ateji.** In my case I had many to choose from. You however should keep the number of characters to three or four at most (Chinese people use only two or three for their names) and the pronunciation should be as accurate as possible. The aesthetic quality of the characters is also vital as well as the combined meanings.

For example "Chris Earnshaw" would be phonetically KU RI SU . ARN SHOW

九里州 安祥

Nine League State . Peace Happiness

紅栗鼠 暗礁

Crimson Squirrel . Hidden Rock

but I chose 栗洲 Chestnut Sandbank.

Avoid mixing the Chinese **on** pronunciation and the Japanese **kun,** in other words **jūbakoyomi.** A Japanese-English dictionary will give the **kun** readings while Nelson's Character Dictionary gives the **on** readings. Once you have decided on your pen name known as a **gō** or **gagō,** do not keep changing like Matsuo Basho the Haiku poet who had more than a dozen **gō.**

139

Many **kanji** written in **kaisho** are made up of elements known as radicals. A knowledge of these is important in finding a character in a dictionary when you do not know the pronunciation, and secondly when you attempt to explain to a Japanese speaker or anyone else for that matter how a character is to be written. This list is not all inclusive. For the entire list see Nelson in the bibliography. These radicals have been compressed so that they will fit into the imaginary square alloted to the construction of the character. On their own they would not normally be written in this manner. The radical indicates the etymological "family" of a word. All **uohen** characters for example, have to do with different varieties of fish and **amekanmuri** characters, are phenomena to do with the weather.

雲	くも	cloud	鯨 くじら	whale
雪	ゆき	snow	鮫 さめ	shark
雷	かみなり	thunder	鯉 こい	carp

kanmuri 冠

ukanmuri	宀 安	anakanmuri	穴 空	
wakanmuri	冖 冗	oikanmuri	耂 者	
kusakanmuri	艹 草	amekanmuri	雨 雲	
takekanmuri	竹 笛	torakanmuri	虍 虎	
hatsugashira	癶 登	nabebuta (keisan) 亠 京		
hachigashira	八 公			

140

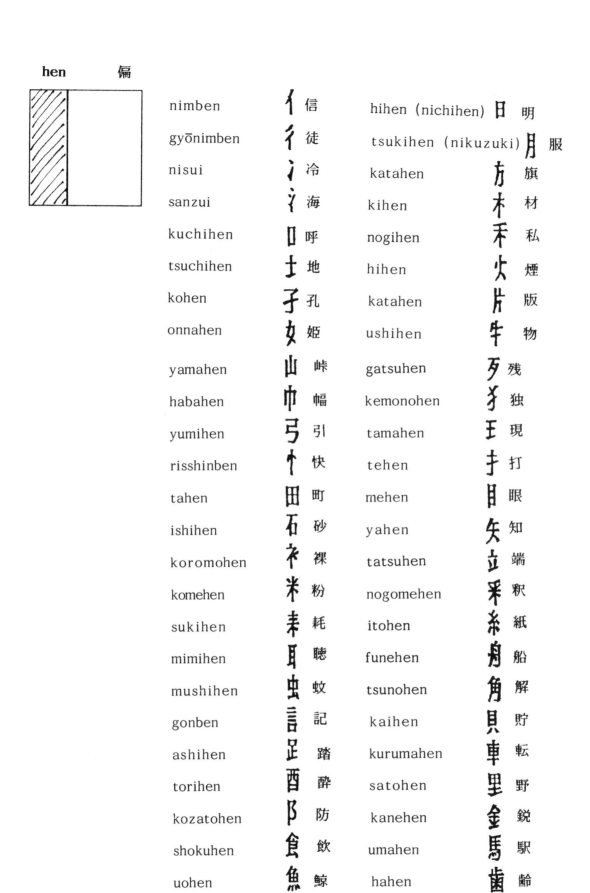

hen 偏

Name	Radical	Example		Name	Radical	Example
nimben	イ	信		hihen (nichihen)	日	明
gyōnimben	彳	徒		tsukihen (nikuzuki)	月	服
nisui	冫	冷		katahen	方	旗
sanzui	氵	海		kihen	木	材
kuchihen	口	呼		nogihen	禾	私
tsuchihen	土	地		hihen	火	煙
kohen	子	孔		katahen	片	版
onnahen	女	姫		ushihen	牛	物
yamahen	山	峠		gatsuhen	歹	残
habahen	巾	幅		kemonohen	犭	独
yumihen	弓	引		tamahen	王	現
risshinben	忄	快		tehen	扌	打
tahen	田	町		mehen	目	眼
ishihen	石	砂		yahen	矢	知
koromohen	衤	裸		tatsuhen	立	端
komehen	米	粉		nogomehen	釆	釈
sukihen	耒	耗		itohen	糸	紙
mimihen	耳	聴		funehen	舟	船
mushihen	虫	蚊		tsunohen	角	解
gonben	言	記		kaihen	貝	貯
ashihen	足	踏		kurumahen	車	転
torihen	酉	酔		satohen	里	野
kozatohen	阝	防		kanehen	金	鋭
shokuhen	食	飲		umahen	馬	駅
uohen	魚	鯨		hahen	歯	齢

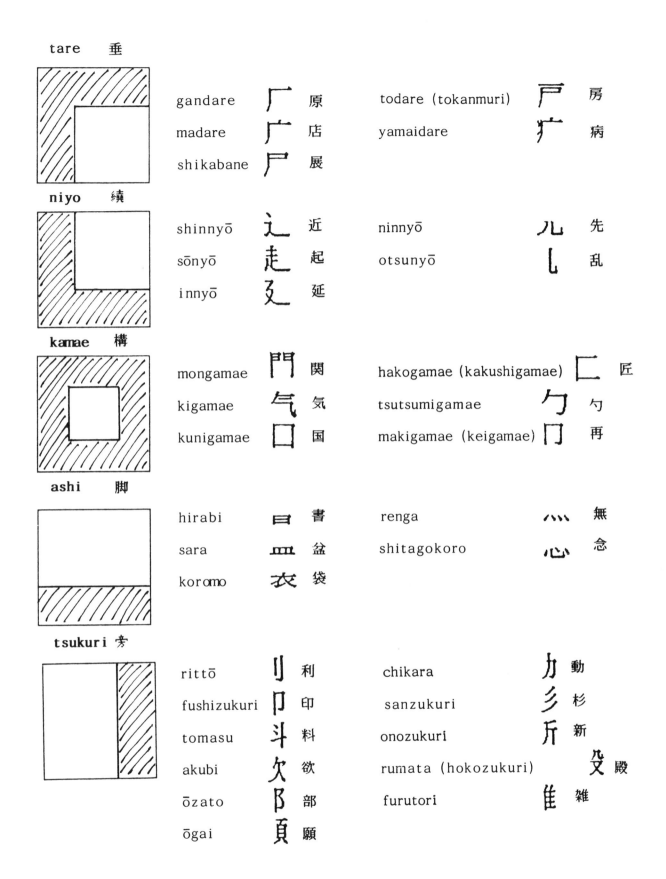

tare 垂

gandare 厂 原
madare 广 店
shikabane 尸 展

todare (tokanmuri) 戸 房
yamaidare 疒 病

niyo 繞

shinnyō 辶 近
sōnyō 走 起
innyō 廴 延

ninnyō 儿 先
otsunyō 乚 乱

kamae 構

mongamae 門 関
kigamae 气 気
kunigamae 囗 国

hakogamae (kakushigamae) 匚 匠
tsutsumigamae 勹 勺
makigamae (keigamae) 冂 再

ashi 脚

hirabi 曰 書
sara 皿 盆
koromo 衣 袋

renga 灬 無
shitagokoro 心 念

tsukuri 旁

rittō 刂 利
fushizukuri 卩 印
tomasu 斗 料
akubi 欠 欲
ōzato 阝 部
ōgai 頁 願

chikara 力 動
sanzukuri 彡 杉
onozukuri 斤 新
rumata (hokozukuri) 殳 殿
furutori 隹 雑

The top row of the box shows the **hiragana** symbol and the lower one, the **kanji** it was derived from. The bottom shows other **kanji** that are only used for calligraphy as they have the same pronunciation.

ko	ke	ku	ki	ka	o	e	u	i	a
こ	け	く	き	か	お	え	う	い	あ
古	計	久	幾	加	於	衣	宇	以	安
故	介 希	具	支 貴	閑 可	隱	江	有	伊 意	阿

to	te	tsu	chi	ta	so	se	su	shi	sa
と	て	つ	ち	た	そ	せ	す	し	さ
止	天	川	知	太	曾	世	寸	之	左
東 登	亭 手	徒 都	遅	多	楚 所	勢	春 須	志	散

ho	he	fu	hi	ha	no	ne	nu	ni	na
ほ	へ	ふ	ひ	は	の	ね	ぬ	に	な
保	部	不	比	波	乃	祢	然	仁	奈
本	邊	布	悲 飛	者 盤	能 農	年	努	尔 丹	那

ri	ra	yo	yu	ya	mo	me	mu	mi	ma
り	ら	よ	ゆ	や	も	め	む	み	ま
利	良	与	由	也	毛	女	武	美	末 万
里 李	羅	余 餘	遊	耶 屋	茂	免 馬	無 舞	三	萬

n	wo	we	wi	wa	ro	re	ru
ん	を	ゑ	ゐ	わ	ろ	れ	る
无	遠	恵	為	和	呂	礼	留
手成越	衛	井井	玉倭	路楼楼	連従禮	流累	

The **katakana** syllabary has been devised by taking a distinctive portion of a **kanji** rather than adopting the **sōsho** form of a character as **hiragana** does.

ko	ke	ku	ki	ka	o	e	u	i	a
コ	ケ	ク	キ	カ	オ	エ	ウ	イ	ア
己	介	久	幾	加	於	江	宇	伊	阿

to	te	tsu	chi	ta	so	se	su	shi	sa
ト	テ	ツ	チ	タ	ソ	セ	ス	シ	サ
止	天	川	千	多	曽	世	須	之	散

ho	he	fu	hi	ha	no	ne	nu	ni	na
ホ	ヘ	フ	ヒ	ハ	ノ	ネ	ヌ	ニ	ナ
保	へ	不	比	八	乃	祢	奴	仁	奈

ri	ra	yo	yu	ya	mo	me	mu	mi	ma
リ	ラ	ヨ	ユ	ヤ	モ	メ	ム	ミ	マ
利	良	興	由	や	毛	女	牟	三	末

		wo	we	wu	wi	wa	ro	re	ru
		ン	ヲ	ヱ	ヰ	ワ	ロ	レ	ル
		牟	乎	慧	井	和	呂	礼	流

The Roots of Kanji

Shōkeimoji, early imitative drawings of objects in life are the philological roots of characters. Originally used for purposes of divination, they originated more than three thousand years ago. Kanji, like hieroglyphics, are essentially pictures which over several thousand years have become so stylized that they are no longer discernible as pictures. The original drawings are to be found scratched on to bones, tortoise shells or bronze ware. The simplicity of form and vivid imagery they convey make them an ideal medium for expressions of sho. Obviously they cannot all be shown here, but here is a sample. Others may be found in calligraphic dictionaries or books referred to in the bibliography.

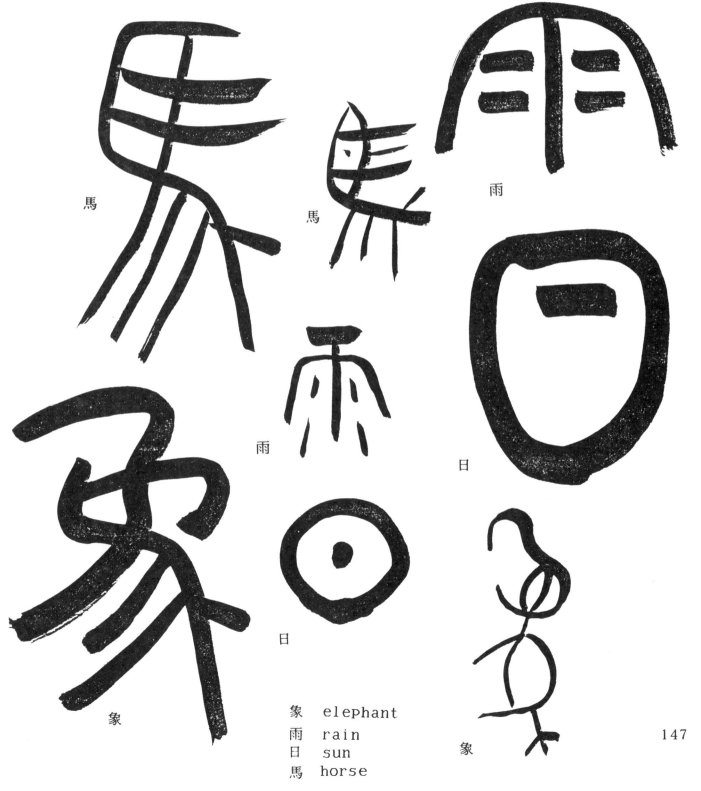

象 elephant
雨 rain
日 sun
馬 horse

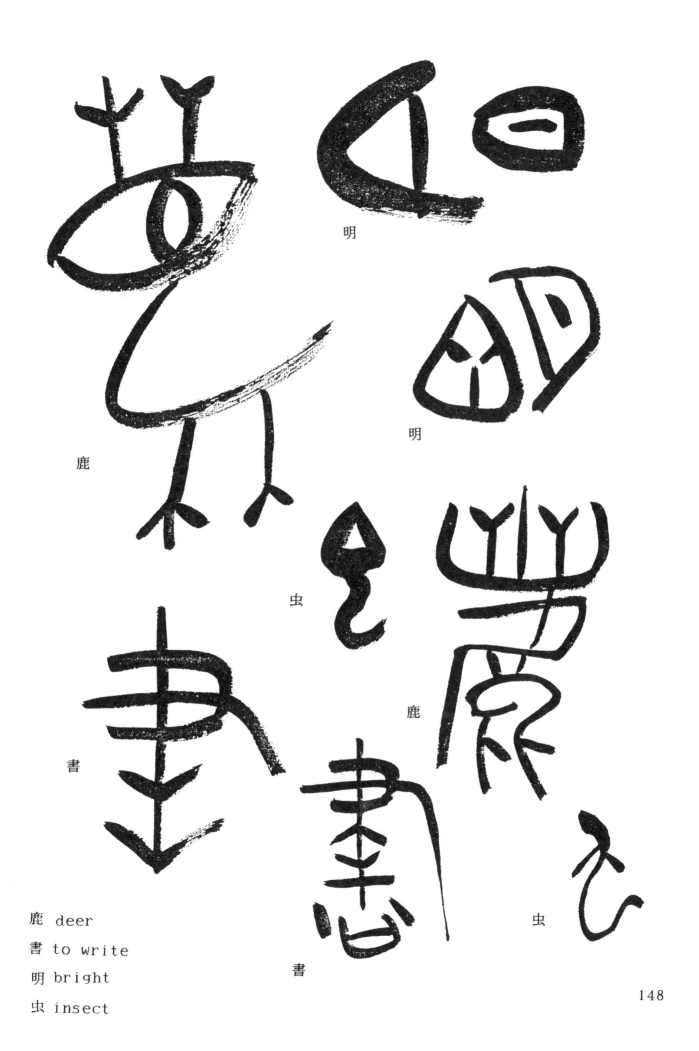

鹿 deer
書 to write
明 bright
虫 insect

148

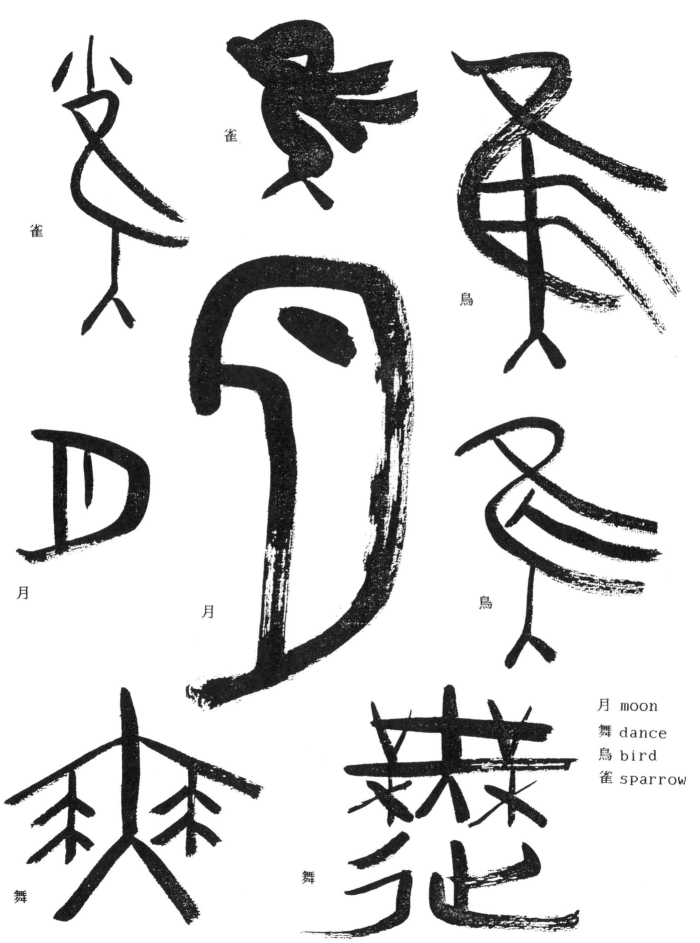

雀

雀

月

舞

鳥

鳥

月

舞

月 moon
舞 dance
鳥 bird
雀 sparrow

149

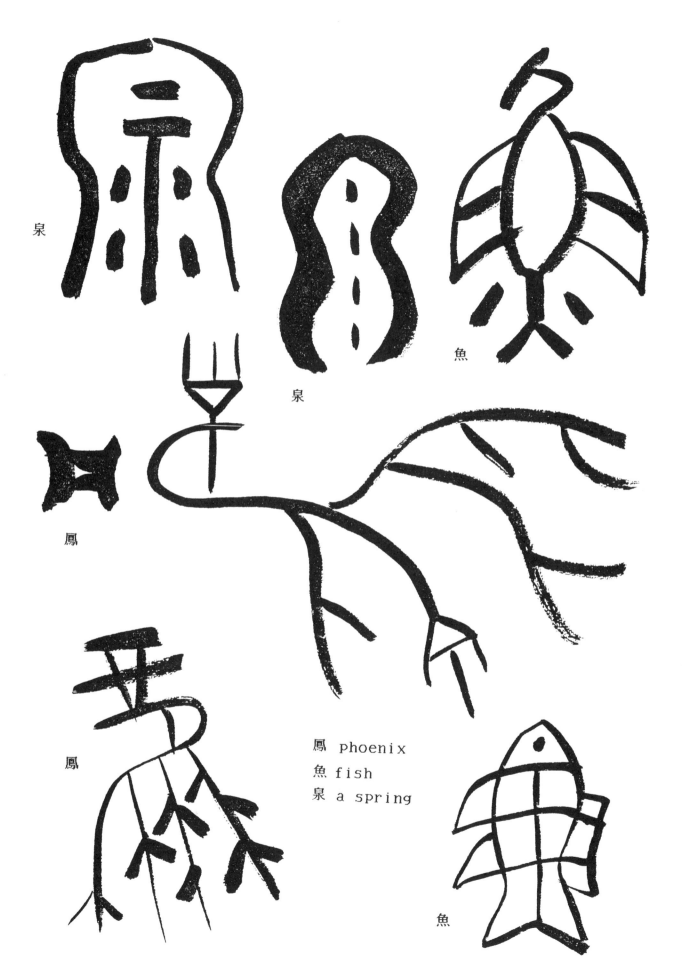

泉

泉

魚

鳳

鳳

鳳 phoenix
魚 fish
泉 a spring

魚

150

Chinese poetry can be described as being classical or modern. The modern period started with the beginning of the T'ang Dynasty in 610 A.D. the poems of the classic period were less structured than the later works and fall into two groups **seigen**, poems of 4,5 or 7 characters and **zōgen** with fewer or more characters than **seigen**. In the modern period poems can be classified into three main forms based on the number of lines rather than the number of characters. Four lines of five, six or seven characters are **zekku**; eight lines of five or seven characters are **risshi** and ten or more lines of five or seven characters are **hairitsu**. The lines are normally in rhyming couplets and there are stresses within the lines, but one would have to speak Chinese to appreciate the fact.

As Japanese and Chinese syntaxes are different, the Japanese have difficulty in reading Chinese sentences **kanbun** or Chinese poems **kanshi**, even though the same characters are often used in both coutries with the same meaning. To overcome this the Japanese developed a method known as **kaeriten**, which is a system of symbols that indicate the order in which the characters are to be read.

⌐ indicates that the characters above and below are to be read in reverse order

‐ = the characters above ‐ and below = are read first, then the clause above = and so on. Reversals ⌐ are to be done as you read through.

written as:	read as:		
飛シテ	羽	"To get drunk from a cup made of feathers at a moonlight feast" (Rihaku)	
羽ウヤ	觴		
觴ヲ	飛		
而	而	The kana at the right of the poem are the **okurigana**--the Japanese verb endings and these do not exist in Chinese.	
醉	月		
月	醉		

In place of the ⌐ ‐ = system of counting others that are commonly used are 上 中 下 and the 甲 乙 丙 series.

Remember these poems should be written right to left (as well as top to bottom starting on the right). The above list of poems have been written left to right for ease of comprehension. For your poems it is best to start by relying on a **Bokujō Hikkei**, a compilation of famous poems and sayings. The poems are usually in groups such as famous sayings **meimonku** 名文句 , the seasons **shiki** 四季 or **kisetsu** 季節 ,poems of appreciation **kanshiki** 鑒識 ,or poems written in moments of quiet self-reflection **kanteki** 閑適. Within these groups they will be arranged by the number of characters per poem. Besides composing the poems yourself another way is to buy an English translation of a Chinese work, for example Mencius, and having found a passage you like, compare it to the original in Chinese - obviously some

151

experience with **kanbun** will be needed. The passage you choose ought to be a wise saying or have some philosophical content, rather than just relating an event.

Japanese poetry to a greater extent is not so complicated as it relies on the number of syllables in a phrase. The three main forms are **tanka, chōka** and **haiku.** A **tanka** is made up of thirty-one syllables, five, seven, five, seven, seven. A **chōka** is of unlimited length being alternately 5,7,5,7 but the last two phrases must end seven and seven. The **chōka** is more of a classical form and is rarely written nowadays. These two forms are collectively known as **waka.** A **haiku** is a seventeen syllable poem made up of five, seven and five, and being shorter are very popular. A unique feature of Oriental poetry is that there must be a reference to the season **kigo** in the poem.

A famous example of a haiku is by Matsuo Basho:

古　池　や　蛙　　飛び込む水　の　音
ふる　いけ　や　かわず　とびこむ　みず　の　おと

An old pond, a frog jumps in, a splash of water.

Here the **kigo** would be the frog representing summer. Often people would add a couplet of seven and seven to the end of a **haiku,** on the same theme. This would then be known as a **renga;** the original **haiku** part of the **renga** is then referred to as the **hokku.**

A List of Chinese and Japanese Poems

Chinese　　サンセイ
三省

Reflect everyday whether you have been faithful in your dealings with other men, truthful to friends and have put to use something you have learnt. (Confucius)

センシン
洗心

Make your heart pure. (Ekikei)

ジシユウ
時習

Study enthusiastically (Confucius)

ム ガ
無我

Through meditation you achieve a state of selflessness **MUGA** (---)

フ ドウシン
不動心

Make an unalterable decision (Mencius)

ボウウン
望雲

Looking at the distant skies and remembering the family far away from yourself. (Teki Jin Ketsu)

カ ガン
花顔

A beautiful woman (Rihaku)

キンシヨラク
琴書楽

To enjoy music and calligraphy (Tōsen)

ウンユウカシユク
雲遊霞宿

As the clouds gambol in the sky, the morning mist plays about the inn. (Rieki)

フ ゲンノキヨウ
不言之教

Teaching by example (Rōshi)

シユンランシユウギク
春蘭秋菊

In Spring orchids are at their best, in Autumn the chrysanthemums, therefore this expression may be used to indicate when something is the best in its field. (Shoyoroku)

153

インシュスベデノノカミ
飲酒全其神

Sakè is the medicine for a hundred ills. (Rikkyū)

リンセントンセイノカン
林泉遯世閑

Leave this world and enjoy the peace of the forests and springs. (Yaritsu Sozai)

ロンシンシュイッソン
論心酒一尊

Drinking sakè from a barrel and speak of one's cares (Mabun Gyoku)

シンジョスイ
心如水

A spirit is like water (Bunchō Mei)

ジンシャジュ
仁者寿

A benevolent person lives a long life (Confucius)

ガクソンシ
学遜志

When studying one must be humble (Shōkei)

カクチョウゴ
鶴聴碁

The dancing crane tilts its head to one side as though listening to the clicking of **go** stones (Kato)

シンフ ザイエンシ ジ フ ケン
心不在焉視而不見

If you are not interested in looking you would not see even if you looked (Daigaku)

センリ ノ コウシ オ ソッカ
千里之行始於足下

Even the longest journey begins with the first step (Roshi)

Japanese Haiku

Spring

<ruby>菜<rt>ナ</rt></ruby>の<ruby>花<rt>ハナ</rt></ruby>や<ruby>月<rt>ツキ</rt></ruby>は<ruby>東<rt>ヒガシ</rt></ruby>に<ruby>日<rt>ヒ</rt></ruby>は<ruby>西<rt>ニシ</rt></ruby>に

The season of rapeseed flowers, the moon is in the east as the sun is setting in the west. (Buson)

<ruby>行<rt>イ</rt></ruby>く<ruby>春<rt>ハル</rt></ruby>や<ruby>鳥<rt>トリ</rt></ruby><ruby>啼<rt>ナ</rt></ruby>き<ruby>魚<rt>ウオ</rt></ruby>の<ruby>目<rt>メ</rt></ruby>は<ruby>泪<rt>ナミダ</rt></ruby>

The song of birds and fish tears lament the passing of spring. (On the occasion of Bashō leaving on a trip to northern Japan.) (Bashō)

Summer

<ruby>五月雨<rt>サミダレ</rt></ruby>を<ruby>集<rt>アツ</rt></ruby>めて<ruby>早<rt>ハヤ</rt></ruby>し<ruby>最上川<rt>モガミガワ</rt></ruby>

Mogami River flows swiftly swollen with monsoon rains (Bashō)

<ruby>桐<rt>キリ</rt></ruby>の<ruby>花<rt>ハナ</rt></ruby><ruby>日<rt>ヒ</rt></ruby>かげをなすにいたらざる

However big the flower of the paulownia, it does not afford shade from summer sun (Kyoshi)

Autumn

<ruby>柿<rt>カキ</rt></ruby>くへば<ruby>鐘<rt>カネ</rt></ruby>が<ruby>鳴<rt>ナ</rt></ruby>るなり<ruby>法隆寺<rt>ホウリュウジ</rt></ruby>

As I eat the fruit of the persimmon, the bell of Horyuji sounds (Shiki)

<ruby>此<rt>コ</rt></ruby>の<ruby>道<rt>ミチ</rt></ruby>や<ruby>行<rt>イ</rt></ruby>く<ruby>人<rt>ヒト</rt></ruby>なしに<ruby>秋<rt>アキ</rt></ruby>の<ruby>暮<rt>クレ</rt></ruby>

I meet no one as I take this path of an Autumn evening (Bashō)

Winter

いくたびも<ruby>雪<rt>ユキ</rt></ruby>の<ruby>深<rt>フカ</rt></ruby>さを<ruby>尋<rt>タズ</rt></ruby>ねけり

I asked many times how deep the snow was (Bashō)

<ruby>梅<rt>ウメ</rt></ruby><ruby>一輪<rt>イチリン</rt></ruby><ruby>一輪<rt>イチリン</rt></ruby>ほどの<ruby>暖<rt>アタタ</rt></ruby>かさ

I can gradually feel the warmth of Spring as each plum bud opens (Ransetsu)

The IROHA Poem

This is a very well known poem in Japan which dates from the Heian Period (794 - 1185). The author is generally thought to have been the Buddhist monk Kūkai. The poem is often the object of practice in calligraphy as it comprises all forty-eight symbols of the syllabary. It is also often used for ranking things. For example the first row of seats in a theatre might be called "I" and the second "RO" and so on.

Translation:

Though gay in hue, the blossoms flutter down also, Who then in this world of ours may continue forever? Crossing today the uttermost limits of phenomenal existence I shall no more see fleeting dreams, neither be any longer intoxicated.

Basil Hall Chamberlain (1850 - 1935)

i	ro	ha	ni	ho	he	to	chi	ri	nu	ru	wo	
wa	ka	yo	ta	re	so	tsu	ne	na	ra	mu		
u	wi	no	o	ku	ya	ma	ke	fu	ko	e	te	
a	sa	ki	yu	me	mi	shi	we	hi	mo	se	su	n

い	ろ	は	に	ほ	へ	と	ち	り	ぬ	る	を	
わ	か	よ	た	れ	そ	つ	ね	な	ら	む		
う	ゐ	の	お	く	や	ま	け	ふ	こ	え	て	
あ	さ	き	ゆ	め	み	し	ゑ	ひ	も	せ	す	ん

以	呂	波	仁	保	部	止	知	利	奴	留	遠	
和	加	与	太	礼	曽	川	弥	奈	良	無		
宇	為	乃	於	久	也	末	計	不	己	衣	天	
安	左	幾	由	女	美	之	恵	比	毛	世	寸	无

色は匂へと散りぬるを我かよ誰そ常ならむ有為の奥山
今日越えて浅き夢見し酔ひもせすん

156

Source List and Bibliography

(There are many more than shown here, but this is a good selection that is readily available).

1. General Use

 a) Yōji Jiten (Ōbunsha) It gives the characters for the Japanese word in **kana**

 b) Japanese-English, English-Japanese Dictionary (Sanseidō)

 c) Gotai Jirui (Seito Shobō) It gives five forms (**kai, gyō, sō, rei** and **tensho** in that order) for 5,000 characters, with their origins: though some of the entries are misleading.

 d) Shodō Jiten (Kadogawa) A very good and detailed shortened edition of the large two volume masterpiece. It is published in the **takuhon** form, and gives more than five styles in many cases. Also has a detailed **kana** section. 8,000 characters plus.

2. Kanji Dictionaries

 a) Simple: Shōgakusei Kanji Jiten (Seibundō Shinkōsha) Written in easy to understand **kana**, but does not include difficult Chinese characters.

 b) Detailed: Kanwa Jiten (Shōgakkan)

 c) Chinese-English (Chūka Shokyoku) or better Chinese-Japanese, useful for obscure characters

 d) A. Nelson's Character Dictionary (Tuttle) excellent with English meanings of Kanji and phrases. Useful notes on the Japanese language

3. Texts

 i) General

 a) simple: Shōgakusei no Shodō Kōza by Uno Sesson (Nigensha) Written for "little adults" in simple Japanese, interesting sections on the history, penji, balance, proportions, takuhon, etc.

 b) detailed: Shodō Kōza by Nishikawa Yasushi, (Nigensha) in eight volumes, one on each **shotai**, with a detailed history and tehons by famous calligraphers.

158

c) Nyūmon Mainichi Shodō Kōza. (Mainichi Shinbunsha) examples and tehons by famous calligraphers, but no history.

ii. Specialist

a) Shodō Gihō Kōza (Nigensha) stroke by stroke introduction to famous works, with detailed photographs or brush control. Series of forty.

b) Shoseki Meihin Sōkan. (Nigensha) These are photographic copies of both sho and takuhon works, showing the original and enlarged detail, with the transliteration in Katsujitai. One book for each word, a series of two hundred and thirty kana works.

c) Kakudai Hoshosenshū (Nigensha) An easy to use large edition of b) with six or eight characters to the two pages that open out flat as an ideal tehon. Series of twelve.

d) Gendai Nihon Shohō Shūsei (Shōgakkan) A set of ten or so books, one each one a famous contemporary calligrapher, his works and tehons in that master's style.

4. Sōsaku:

There are very few good books dealing with this directly. For **jōfuku**, which also indirectly applies to other works, there is **Jōfuku no Kakikata** (Nichibō Shuppansha) that is both detailed and critical. The final pages of Daitō Shodō Magazine (Daitō Bunka Shodō Centre) gives good guides. Apart from these the best way is to see what is being done at the present. For this the magazine **Sumi** is excellent (Geijutsu Shimbunsha). It deals with all the major exhibitions, interviews with masters and the more unusual history of calligraphy. Visits to exhibitions can be very enlightening, take a camera (which is permissible in Japan) and keep a scrapbook for reference.

5. Inkan

a) How to make them: a pamphlet called Tenkoku (Nihon Kyōiku Kyōkai)

b) Chinese Seals by T. C. Lai. (University of Washington Press) Many examples of famous seals and bits of history

Dictionaries especially for tenkoku:

 i) Rokutai Inkan Jiten (Kwong Chi Book Company, Hong Kong)

 ii) Kinseki Jikan (Chushin Shokyoku Hong Kong)

6. Kokuji

 The dictionaries above 5i and ii are good supplements to 1c and d.

 Gendaikokuji Kōza (Nichibō Shuppansha) part 1, good introduction to how to do kokuji; part 2 introduces famous kokuji artists and their works (N.B. p. 62, Sugano Sensei writing directly onto the wood without a kagoji!)

7. Sōsho dictionary:

 used for finding what the original character might have been; it has a very original classification system Kuzushiji Kaidoku Jiten (Kondō Shuppansha)

8. Books of Poems for Calligraphy;

 they are either set out by seasons, or arranged in the number of characters to the poem.

 simple:

 Sho no Shiori (Nigensha) These are not in kanbun and are self explanatory. Good for tehon practice.

 detailed:

 a) Bokujō Hikkei (Seigadokan) compact with kanbun marks but without an explanation.

 b) Bokujō Hikkei (Ōbunkan Shoten the "classic" with both short and long poems-longer than fourteen characters, with Kanbun marks, furigana and explanations.

 c) Chūgoku Meishi Kansho (Kadogawa Shoten) Not exclusively for calligraphy, but very readable, having a selection of some of the best poems in author order and explained in depth.

 d) Shinshū Bokujō Hikkei (Hosei University Shuppankyoku) In three slim volumes, one being exclusively Japanese poems, very good for kana/hentaigana works. Varies from two characters to fourteen, with explanation and kanbun marks.

9. How to read Kanbun

 Kanbun Kaidoku Jiten (Kadokawa Shoten) very detailed and thorough, but also in very difficult Japanese.

10. The written order of kanji

 a) Written Introduction to Japanese (English Universities Press) P.G. O'Neil

 b) Kakikata Jiten (Nobarasha) Pocket edition

11. History of Calligraphy

 a) The Art of Japanese Calligraphy (Weatherhill) very detailed, but heavy going.

 b) Ji to Sho no Rekishi (Nihon Shūji Fukkyū Kyōkai), in easy Japanese, giving and entertaining and broad picture.

 c) Sho no Rekishi (Nigensha) a detailed textbook.

 d) Shodō Koten V. I,II, III (Nigensha). A textbook written by and for Daitō Bunka University. A very straightforward book with excellent illustrations and photographs.

12. On the Four Treasures

 Bunpō Shihō, Nagai (Tankōsha) Four volumes in the set, with everything you could want to know. It includes samples of various types of paper.

13. Specialist dictionary of technical terms and theories

 Shosha, Shodō Yōgo Jiten (Daiichi Hōki). A very good and much needed shortened version of the great Shodō Jiten that was twelve times the size and price.

14. Specialist book on teaching calligraphy in schools

 Shosha, Shodō Kyōiku Genri (Kōdansha) The last word on the subject.

15. On teachers and schools

 Bijutsu Meiten and Bijutsu Nenkan (Geijutsu Shinbunsha). It is expensive to have one's name included, but as they are voluntary many teachers are not in it.

16. Introductory books on calligraphy in English

Chinese Calligraphy, T.C. Lai (University of Washington Press) and Chinese Calligraphy, Chiang Yee (Methuen) both are written very much from a Chinese point of view, with little or no mention of Japanese calligraphy. Chiang Yee's book is rather "dated."

Mi Fu, Lothar Ledderose (Princeton) on Chinese calligraphy in general and Beifutsu, (Mi Fu) in particular

Traces of the Brush (Yale University) excellent, especially the section on forgeries.

Chinese Calligraphy, L. Driscoll, K. Toda

Chinese Calligraphers and Their Art, Ch'en Chih-Mai

Japanese Ink Painting and Calligraphy, Hisao Sugihara

17. The Treasures of Taiwan

A fascinating book in Chinese, Japanese and English on the treasures at the National Palace Museum in Taipei. Most of the works were smuggled out of China when the Nationalist government set up the Republic of China on Taiwan. A rare chance to see previously "lost" classics. Until recently most Japanese masters, being unable to enter China and see the original works, have only had access to these and similar works. Published by the Republic of China, but printed in Japanese by Nissha.

18. On Korean Works

a) Chōsen Kinseki-ko S. Katsuragi

b) Yong-Yun Kim. A biographical dictionary of Korean artists and calligraphers.

c) Han'guk Yesul Ch'ongram - Academy of Art, Seoul, Korea

19. Others:

Nigensha has a free catalogue of all its books that is published yearly

GLOSSARY

A

agari - the finishing stroke of a chisel

arumihaku - aluminium foil

ashi - a character radical

ateji - Kanji used in the phonetic sense

atsugami - thick paper

B

baiyakuzumi - a 'sold' ticket

benmen - a round fan

bi - beauty

bōfuzai - antiseptic used in sumi

bokueki - ready made ink

Bokujō Hikkei - A book of texts for calligraphy

bokujū - ready-made ink

bokuseki - calligraphy done by Zen priests

bokushoku - 'colour' of the ink

bunjin - a literati

bunpō shihō - The Four Treasures of Calligraphy

byōbu - a folding screen

C

chekku - check

chō - the system of numbering used with sumi

chōka - a long form of Japanese poetry

chōwa - harmony

chōwatai - a mixture of kana and kanji

chūbude - middle sized brush

163

ch'usa - Korean kaisho

chūshin - centre of a character

D

dai - title of a work; also a working bench for kokuji

daiten - greater seal script

Do - See Eiji Happō

E

Eiji Happō - the eight basic strokes

ekitaiboku - liquid ink

enso - circles written by Zen priests

eto - used in counting years

F

fūchin - weights hung from the spindle of a hanging scroll

fude - brush

funori - glue used in sumi

fusuma - heavy sliding screens

fuyuge - an animal's winter coat

G

gagō - a pen name

ganpi - a plant used for making paper

ginpaku - silver foil

gōgōhitsu - hard, springy brush

gagōin - seal engraved with a pen name

gō - the numbering system used for brushes

goku - text of a poem

goji - incorrectly written characters

gyōsho - semi-cursive script

H

haiku - a style of Japanese poetry

hairitsu - a type of Chinese poem

hakubun - seal with a red background

hanko - everyday seal

hansetsu - a size of paper

hanshi - paper for shūji

hanryu - decorative paper used for kana

hen - a character radical

heragami - backing paper used in hyōgu

hi - a memorial stone carved with characters

hibun - the text of a carved stone monument

hihaku - "flying white", a form of zattaisho

hikkan - handle of a brush

hiragana - the cursive form of the Japanese syllabary

hissei - the power in a line

hitonigirihan - length of a brush handle

hitsui - the inner feelings at the moment of writing

hokoboku - forgeries of old sumi

hōmeichō - visitor's book

Hsi Hsia - a form of Chinese character

Hsin yin - "Heart Prints"

hyōgu - backing for written calligraphy

hyōsatsu - name plates on houses

I

in - seal

inbun - the text of a seal

inkan - seal

inkanshōmeisho - certificate of having registered a seal

inko - a rough copy of an inbun

inku - a set square for impressing a seal

inniku - red ink pad for pressing seals

inochige - the single strong hair in the center of a brush

inpu - a book of artist's seals

Iseyama gire - a collage of different papers used in writing kana

Ita - a piece of wood for kokuji

J

jiku - the handle of a brush

jimmeiji - characters used for names

jō - emotion

jōfuku - a size of paper

jōyōkanji - a series of characters approved for daily use

jūbakoyomi - onyomi and kunyomi intermixed in a phrase

jubokudō - a classical expression meaning calligraphy

jūgōhitsu - a very soft brush

jūnishi - the zodiac used in counting the years

jyakutō hitsu - short "sparrow's head" brush

K

kaō - monograms

kadō - flower arranging

kaeriten - a symbol used in reading kanbun

kagoji - a tracing used in kokuji

kaisho - standard script

kakejiku - a hanging scroll

kakijun - the order for writing a character

kamae - a character radical

kaku - a stroke

kamakura bori - a style of decorative carving

kami - paper

kana - Japanese syllabary

kanbō'in - a form of seal

kanbun - prose written in Chinese read in Japanese

kanejaku - a steel ruler

kanga - integral spacing of lines and dots within a character

kanji - a character

kanjō - a classical name for a brush

kanjōshi - brush maker

kammuri - a character radical

kanshi - a Chinese poem read in Japanese

kanshiki - poems of appreciation

kantaku - a dry method of takuhon

kanteki - reflective poems written in quiet surrounds

karagami - Chinese paper

karayō - classical Japanese calligraphy reflecting Chinese
 influences

kasure - a line where the ink runs out

katakana - the Japanese used for transcribing foreign words

katamefude - a starched brush

katsujibunka - culture based on the printed word

ke - hair of a brush

kekkōhō - the structure of a character

kengaku - a small hanging scroll

kengohitsu - a brush hard inside and soft outside

kigo - an allusion to the season in haiku

kikaizuki - machine made papers

kindaishibun - a school of calligraphy practising chowatai and
 using modern poetry

kinpaku - gold foil

kisetsu - the season

kizuchi - a mallet

koan - a Zen conundrum

koboku - antique sticks of sumi

kobun - classical Japanese literature; also antique scripts

kokeiboku - solid ink

kōkotsumoji - primitive characters etched into bone

kokuji - carved calligraphy

kōryō - scent used in sumi

koyagami - decorative paper used for kana

kozashiki - four and a half mat rooms used in the tea ceremony

kūkan - white spaces between lines and characters

kunyomi - the Japanese pronunciation of a character

Kyōiku Kanji - the minimum number of characters that have to be
 learned each year in primary school

M

makimono - scroll

meimonku - famous saying

menkyojō - license, often written on paper or wood

mitsumata - a plant used for making paper

mizubake - a brush for applying water

mokkan - ancient strips of bamboo with characters written on them

monku - contents of a poem

monku no kokoro - the real meaning of the words in a koan

n

nami - wave pattern

natsuge - an animal's summer coat

neriboku - concentrated bokuju

netsuke - a decorative toggle

Nezumizan - compounded calculation

Nihonga - western style paintings using Japanese themes and
materials

nijimi - the edge of a line becoming blurred as the ink is
absorbed by the paper

Nijūkaki - writing over a line the second time

nikawa - vegetable glue

niyō - a character radical

noboku - thick ink

nomi - chisel

noribake - a glue brush

noshibukuro - a decorative envelope for donating money

noshigami - decorative paper for placing on a present indicating
who sent the present

O

obori - characters carved into the wood

ochagake - a small hanging scroll used in the tea ceremony

okurigana - verb endings, etc. in kana between the characters in
a sentence

omote - front

onyomi - characters pronounced after the Japanese adapation of
Chinese pronunciation

otokode - A masculine form of kana

onnade - a feminine style of written kana

R

rakkan - the dedication and signature at the end of a work which
 includes the seals

rakkanbun - the contents of the rakkan

rakusei no kanshi - see rakkan

rei - see reisho

reisho - the scribe's script

ren - a paper size

renga - a series of haiku or haiku and reply

remmentai - chains of characters and kana joined up

renochi - a paper size

rinsho - copying a famous work

risshi - a type of Chinese poem

roku - see Eiji Happō

ryō - see Eiji Happō

ryūyō hitsu - long "willow leaf" brush

S

sabaki fude - a brush with loose unstarched hair

sadō - the tea ceremony

sakuhin - a completed work

sanpitsu - see the history section

sanseki - see the history section

sekkaboku - an ink stick used in takuhon

seigen - a type of Chinese poem

seimei'in - a seal engraved with your family name

seishintōitsu - mental concentration

seiyōshi - western style paper

sen - a line

sensu - folding fan

shaban - company seals

shaku - a measurement equal to 0.994 feet

shibu - a stain used in kokuji

shikishi - a size of paper mounted on a card

shihitsu - the point where the brush first touches the paper

shirobake- a brush with stiff bristles

shitajiki - cloth under hanshi

shittaku - wet method of takuhon

sho - calligraphy

shodō - the way of calligraphy

shōenboku - grey ink made from the smoke of pine needles

shōfu - glue for hyogu

shōjisu - works comprised of one or two characters

shōkeimoji - ancient characters often hieroglyphic in form

shosha - copying calligraphy for practice

shōten - lesser seal script

shuboku - teacher's red ink for corrections

shubun - a seal with white background

shudai - theme

shūji - copying calligraphy for practice

soku - see Eiji Happō

soroban - an abacus; mathematics

sōsaku - creating a work

sōsho - "grass" script

shihitsuban - special paper that needs no ink, used for
 practicing shūji

sui ren - a pair of Chinese hanging scrolls

sumi - inkstick

sun - a measurement equivalent to 1.193 inches

suzuri - inkstone

T

taku - see Eiji Happō

takuhon - making a rubbing of calligraphy carved in stone

takumi - skillful, dextrous

tamaishi - a square memorial stone

tanboku - thin, watery ink

tanka - a short form of Japanese poetry

tanpo - ink pads used in takuhon, also "short blade" brushes

tansaku - a size of paper used in kana works

tare - a character radical

teashi - the fibres at the ripped edge of a piece of paper

tehon - example of calligraphy for shūji

teisei'in - a seal for correcting a document

ten - a dot, also abbreviation of tensho

tengaku - the inscription at the top of a memorial stone

tenkoku - carving seals

teppitsu - a fine chisel for carving seals

tensho - the seal script

tezuki - handmade papers

tokonoma - a corner of a Japanese room used for displaying works
 of art

tonoko - polishing powder for hyōsatsu

tōhitsu - Chinese brushes

tōshi - Chinese paper

totsubori - characters standing proud of the wood

tōyōkanji - a series of characters approved for general use in daily life, etc.

tsukuri - a character radical

tsuriganezumi - an ink stone used in takuhon

Tui ren - a pair of Chinese scrolls

U

uchiwa - a round fan

ukiyoe - a genre of woodblock printing begun in the Edo Period

urauchi - a simple form of hyōgu

W

waboku - Japanese sumi

waka - a Japanese poem

wahitsu - a Japanese brush

washi - Japanese paper

wayō - a form of Chinese calligraphy indigenous to Japan

Y

yaku - see Eiji Happō

yatate - a brush with ink in a traveling container

yomi - reading, also the pronunciation of a character

yōmō - sheep's hair brush

yū'in - a form of seal

yuseiboku - sumi made from the soot of burning vegetable oil

Z

zattaisho - decorative characters

zekku - a type of Chinese poem

zen'ei - abstract calligraphy

zenshi - the largest size paper available commercially

zōgen - a type of Chinese poem